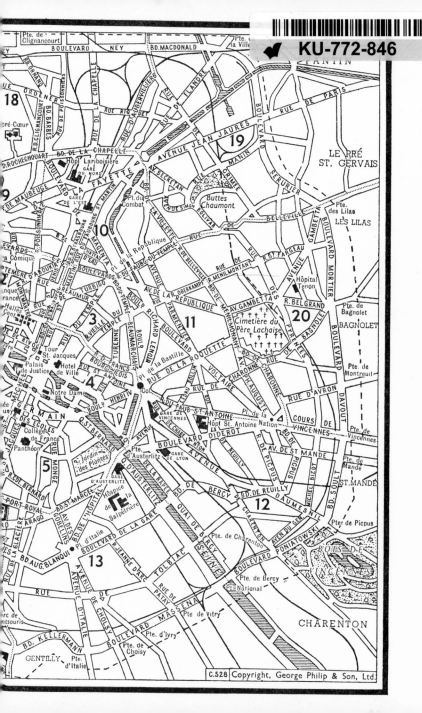

C.528 Copyright, George Philip & Son, Ltd.

PAINTERS' PARIS

BARBARA WHELPTON

PAINTERS' PARIS

★

JOHNSON

LONDON

First Published 1970

S.B.N. 85307 076 8

SET IN 11 ON 12 POINT BASKERVILLE, PRINTED AND MADE IN GREAT BRITAIN
BY CLARKE, DOBLE AND BRENDON LTD., PLYMOUTH
JOHNSON PUBLICATIONS LTD., 11/14 STANHOPE MEWS WEST, LONDON, S.W.7

LIST OF CONTENTS

VI

THE ILE DE LA CITÉ AND THE EASTERN SECTOR

VII

THE WEST END

VIII

THE MAJOR MUSEUMS

IX

MONUMENTS AND MUSEUMS IN THE WEST

X

EXCURSIONS

XI

WHAT TO DO ON SUNDAY

XII

PAINTERS' COUNTRY

APPENDIX I

APPENDIX II

INDEX

MAPS OF ENVIRONS OF PARIS

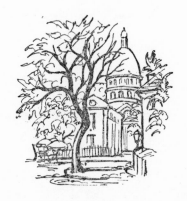

I

INTRODUCTORY

To many people Paris is the most beautiful city in the world and certainly to most painters it provides the ideal atmosphere of stimulation, serious appreciation of all forms of art and freedom of expression. It is true that London has gained greatly in artistic importance during this century and has, for long, organised exhibitions of world-wide interest. Painters of international repute live and work in the capital, but there is still not quite the atmosphere—an ambience at the same time astringent and sympathetic—so evident in Paris. Rome and Florence have as many museums and monuments; Athens has a more ancient civilisation and New York has splendid art collections and modern galleries which vie with those of the French capital, but Paris continues to draw artists from all over the world. Professional painters, art students, amateur artists and anyone who is even mildly interested in art are irresistibly drawn to Paris where they often find they can work better and gain more inspiration, in the

9

city itself and in the surrounding countryside, than in any other country.

The artist is accepted as a vital part of the life of France and is even cherished; here he is esteemed and given privileges in a city where painting and creative art are looked on as work and not as a pastime nor as occupational therapy. He can set up an easel almost anywhere without causing an 'obstruction', though passers-by may gather to take interest in his work. *Bona fide* art students—even foreigners—can eat at special, cheap restaurants. In Paris there are far more cafés where painters congregate than in other cities and these are not only to be found in the 'tourist' artists' centres such as St Germain-des-Prés, the Buci, Montmartre and Montparnasse. Studios abound in every quarter from the *de luxe* to the garret, but are all very hard to come by nowadays, so much so that serious young—and old—painters tend to live far from the centre in quarters unknown to tourists as yet, but which are rapidly becoming amusing and full of life and character.

There are a very large number of artists' shops in all the areas where painters live and work and they are run by people who really know their job and who also treat their customers as professionals, knowing theirs. I cannot remember being unable to get the rarest of materials in any of these shops, nor being told that certain things 'aren't used any more'. Even such small articles as a rubber or sketch book are sold with care and attention. Indeed these places are a paradise to painters from most other capitals, though I must admit to knowing at least three of the same type in London.

There are literally dozens of small galleries on the Left Bank where it is not too difficult for a young painter to give a show and, even today, good prints, rare books and coins can be picked up from the bookstalls along the quays by searching patiently. A large number of shops are devoted to the display of superbly produced art books; posters of a high quality,

publicising art shows, are displayed in cafés and antique shops and even those designed by foremost artists can often be bought for a reasonable sum. They used to be acquired free by the persistent collector who haunted the galleries after exhibitions, but now some of those designed in the nineteenth and early twentieth century fetch good prices as 'antiques'.

I am not for one moment suggesting that life in Paris is cheaper than elsewhere, although there are ways and means for the artist to mitigate the cost of living, even including the possibility of earning a little money by working a few hours a week in a number of—more or less boring—jobs. But life for a painter is considerably easier here than elsewhere and even the foreigner on a short stay can draw by the hour from life or take a short course in art at one of the *Académies* and, for the landscape painter, the countryside is still close at hand and easy to reach.

Even with all these advantages, Paris has only comparatively recently become a settled art centre. In the fifteenth century, painters, and more especially craftsmen, moved with the Court to the banks of the Loire where fine tapestries were woven; in the seventeenth century, Versailles was filled with artists summoned by Louis XIV to carry out the decoration of his *château*. It is not really until the nineteenth century that the capital took on its present role of attracting painters from all over the world to work and live there. This coincided with the beginning of the liberation of art from the meticulous representation of accepted themes, and at a time when painters were leading colourful 'bohemian' lives, often in abject poverty it is true, but none the less considered romantic and exotic by those who did not share in them.

Haussmann, with his ambitious building programme, was letting light and air into the crumbling, ancient quarters of Paris and at the same time, of necessity, destroying much that was attractive. Independent spirits among the painters were

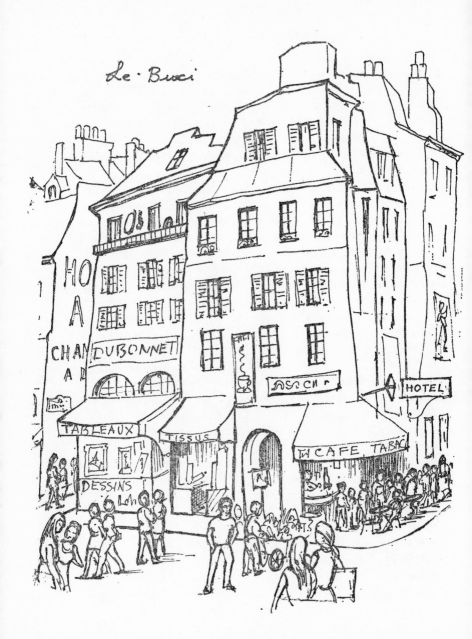

breaking away from the gloomy style and idealised subject matter of their predecessors and the Impressionists were beginning to recreate the world around them, full of atmosphere and flooded with light, and presenting it to us in a new and wonderful way. This was no longer a world of nymphs and goddesses borrowed from earlier centuries, nor a world of epic events pompously portrayed, but a real and familiar world, the world of Paris and the countryside of France, seen as it had never been seen before and imbued with a magic which enlarged the experience of anyone who appreciated it.

Just as Giotto had re-set the Bible stories in the familiar world of the Italian countryside and broken away from the symbolic backgrounds and set, golden skies of Byzantine Art, so the Impressionists spread before us the real living world in contrast to the idyllic woods and pastures and romantic ruins of the academics. Moreover they brought brilliant glowing colour to it, unveiled by dark varnish. Helmut Ruhemann, in his erudite book on the cleaning of pictures, has suggested that the Impressionists and other modern movements might never have existed if some of the earlier paintings had been stripped of their varnish and cleaned to reveal the original colours which had darkened to a uniform series of dusky browns and reds.

Interesting as this theory is, it seems unlikely in the case of the Impressionists, for they were not solely preoccupied with colour and light, but with a whole new vision of the possibilities of paint. They opened the way for all types of subject matter and technical methods to be accepted and, though they themselves did not paint abstracts, they had made so complete a break with tradition that abstract art was a possibility. In doing so, they met with great opposition and, to begin with, found it very hard to make a living; they chose the shabby cheap colourful districts of Paris; they lived unconventionally and fully and they talked—they discussed, they argued—and by so doing created a perfect atmosphere in which painters

could develop their ideas. Even to-day, nearly half a century after all these men have lived, thousands of people visit Paris to try to recapture in Montmartre and other quarters the atmosphere of how they lived and worked. Many people's conception of Paris has been directly dictated by the paintings the Impressionists have left. In them they reveal the Paris, the Ile de France, the Normandy many visitors like to think still exists. They portray the Paris of horse cabs, of bearded frock-coated *boulevardiers*, of elegantly dressed women and gay night life; but also the Bohemian's cafés, the absinthe drinkers, the prostitutes, the sordid tenements.

The Impressionists and their followers, are inseparable from Montmartre and the banks of the Seine. Claude Monet, Renoir, Pissarro, Sisley and many others spread before us Paris and the Ile de France as places to know and to love, to live in, to work in and to enjoy. Yet for them they were already being spoilt and the countryside was being encroached upon. Paris—the ancient, picturesque and squalid Paris—was disappearing under vast new building schemes, and Montmartre on the hill, the little village of windmills and vineyards so recently really dangerous and vice-ridden, was now easily accessible from the Capital and as safe as anywhere else to anyone reasonably sophisticated.

These painters may have felt, as so many artists had felt before them, that the life they understood and the things that meant so much to them were slipping away, and they were therefore passionately anxious to catch the fleeting moment and hold it on canvas. It is often this feeling of something elusive, like a sound, a taste, a smell or even a degree of heat or cold which they evoke which gives their work such a widespread appeal to-day. Nevertheless, it is infused with great permanent qualities and suggests something far more lasting than a mere transitory effect.

When many a lovely, ancient building was pulled down to

make way for Haussmann's great scheme of wide boulevards, better communications were making the village of Montmartre just another district of Paris. Nevertheless, in his own way, or rather by following the ideas of Napoleon III, Haussmann was adding to the grand, monumental lay-out of Paris and opening up great vistas of the outlying country.

With all this change, there remain whole quarters of Paris which retain much of their ancient charm. Not least of these is the tourist-ridden *Butte* of Montmartre, artists' quarter now only in name, for none but the well-established can afford to live there and there are no cheap studios to be found for the struggling student. Nevertheless, Montmartre will always have a fascination, for many of her old houses and inns are still standing, though admittedly, in their owners' efforts to keep them in character, some have out-countrified the original buildings. The farmsteads and all but one of the windmills have vanished, and so have the plaster quarries which were threatening to undermine the village with their widespread excavations. In spite of this, the Place du Tertre remains a place of enchantment on a winter afternoon when no tourists are about. The setting sun spreads a warming glow over the crumbling façades, the slender trees are silhouetted against the patchwork of painted doorways, and, here and there, they break the attractive uneven roof line as they reach up to the softly greying sky. In the very early morning, even in summer, the life of a quiet village is carried on by the permanent inhabitants.

The house where Van Gogh lived still stands in the rue Lepic that winds up the hill from the Place Blanche. The *Moulin de la Galette*, where Renoir painted his famous picture, and where Toulouse-Lautrec often used to draw when he found the energy to climb the hill from his studio below in the Avenue Frochot, still has dancing in the garden, though the *clientèle* is somewhat different and the structure has been

completely restored. *A la Bonne Franquette* still opens its
doors and its gardens to a cheerful sight-seeing crowd, and a
tablet proudly proclaims that it gave hospitality to many
famous men. The vineyards still produce grapes, and free wine
flows at the *vendage* every autumn.

The ancient little church of St Pierre, one of the oldest in
Paris, crouches beside the great vulgar splendour of Sacré
Coeur which did not break the Montmartre sky-line until the
last quarter of the nineteenth century. It was only begun in
1876, when Monet and Sisley and Renoir were well over thirty
and Van Gogh over twenty. Such a gigantic project took years
to realise and when the Basilica was consecrated in 1919, most
of the Impressionists were dead, or, like Claude Monet, living
out of Paris.

In those days the *Butte* was really a village with straggling
gardens, country lanes and a sophisticated night life supplied
by cabarets and dance-halls and cafés. It spread from the
Montmartre of the Place Pigalle and the Place Blanche, with
its circuses and music halls and its meeting places such as the
Café Guerbois and the *Nouvelle Athènes*, which became almost
clubs for painters and writers and the advanced thinkers of
the period. All around was as much exciting night life as any-
one could desire.

The Impressionists and their group tell us a great deal
about this Paris. Theirs is no mere descriptive record, but a
living, pulsing expression of a vital city. If we recall some of
their more famous pictures, we have a very fair idea of the
appearance of Paris in the late nineteenth century. There is
movement but seldom repose, since Paris is a city of movement,
always developing, always changing, always ready to infuse
new ideas into an ancient setting. No one aspect is the true one.
Today, in a cold grey mist, the town is pale and elusive. Shades
of white and grey and violet pile up against each other to form
buildings and bridges whilst the fantastic roof line gives relief

with its warmer glow of pink chimneys against grey-green man-sards. Tomorrow everything may be changed to blue and gold, with the flicker of young leaves and the white of fleecy clouds, no longer mysterious, but still with moving, hurrying or linger-ing figures, rumbling traffic and trees bursting into leaf or shedding them on to the pavements, while boats glide by or chug down the river. In autumn everything else may lose its interest compared with the glory of the riverside, aflame with the brilliance of foliage.

Perhaps this period in Paris has been over-romanticised, and yet it is an epoch when people lived intensely rather than dreamed; a period when artists of all kinds were struggling for success and positively working to achieve a reputation and, by looking at a few of their better-known paintings, we can evoke not only Paris of the late nineteenth century but an atmosphere which can be felt even today.

Pissarro's paintings of the busy life of Paris, of the famous landmarks, mostly done at the end of his life and from windows high above the city, are perhaps more evocative than any. The famous *Boulevard des Italiens* is so full of atmosphere in the morning sunlight, that the outdated aspect of the horse buses and cabs does not seem unreasonable. It is a picture which catches a fleeting moment of morning sunlight, a light which could equally well have shown ancient Rome at its loveliest, or transformed a Midland town. The painter has caught the feeling of the early hours, with saffron yellow, pink and ochre in all its brilliant gradations. But the light is a developing light, and seems to be just on the point of turning to the mid-day glare which will drain away all this enchanting colour.

In another painting of this same street from the same upper window, it is afternoon. The brilliance of the light is fading, the shadows are lengthening and the colours are deepening into violet and dusty rose, and in a few minutes they will be

softening into an evening haze. In some way impossible to analyse, the bustling movement in the morning picture is a setting out, and the equally active figures and traffic in the afternoon picture, are returning home.

Pissarro saw the essentials of this vivid, moving picture which gives us the character of the place. It still has that character, for there are the same types hurrying along, the same gossipers stopping for an argument, even the same kiosks, and of course the same glancing, flickering shadows that transform any Paris street.

If the Boulevard des Italiens is unchanged in pictorial essentials, so also is the Gare St Lazare. Although the lines of the railway engines may be modified and the general amenities have been brought up to date, there is the same feeling of anticipation found today in this pleasantest of Paris's main stations. There is the same puffing, busy, bustling excitement as each train comes in or leaves, as though it were the first time such an astonishing thing had happened. The same sunlight filters through and lends radiance to the rather shabby, tall houses beyond, and gives the same impression of having arrived at a destination of great promise. In the *Gare St Lazare* in the Louvre and in the *Pont de l'Europe*, a painting of the same station now hanging in the Marmottan Museum, Claude Monet portrays light through steam and smoke, and buildings partly in sunlight, partly veiled, and the district has much the same aspect today, though only Monet could have combined the yellowish façades of the dingy houses, and their blue roofs, to make such a fascinating scene.

Claude Monet also painted the Paris street scene and the parks. His *Tuileries Gardens* with the corner of the Louvre, is a convincing study of brilliant sunlight, of clear colours, green and blue and yellow, and of moving cloud effects seen from a height. It spreads over a vast area and emphasises all the spaciousness and grandeur of this part of Paris.

In the same painter's golden picture of the *Boulevard des Capucines* at Carnival time, the trembling branches of the trees move gently against the paler buildings on the other side of the street; the firm lines of the light shop blinds break the crowds swarming along the pavement, and the silk-hatted figures on the balcony look down on the cheerful people celebrating below. We could look from a window today and have almost the same impression.

Seurat, in his *Ile de La Grande-Jatte* gives all the gaiety of a Paris pleasure park combined with a classical sense of composition and repose. This picture has only the *atmosphere* of Paris of today for, unfortunately, the Grande-Jette is now unrecognisable and no reasonable person would spend warm summer Sundays enjoying the grass and trees and fresh air there. A few trees remain, but apart from these, the once popular pleasure island is just another quarter of Paris, and a rather dull one at that. However, Seurat's painting has the national characteristics of sedateness mixed with abandon still to be seen in France on Sundays and holidays; the carefully dressed children out with their parents, very neat and conventional, the workman relaxing on his day off, fashionable women displaying smart clothes, and the ordinary populace enjoying itself in the normal way of the times. Seurat's figures are not cold, nor idealised, but they do not take part in an event actually in process. They belong to something beautifully remembered and set down in perfection.

Renoir is different. He chose to paint only the positively pretty aspect of Paris, the flowers, the blossoming trees, the summer dresses and rose-trimmed hats, girls lying in the long grass and posing in his delightful garden in Montmartre. He has created a beautiful nostalgic picture of the Place de la Trinité, although it is hard to believe that the square, now ugly and crowded, can ever have looked so attractive. But Renoir saw and stressed colour, gaiety and charm everywhere.

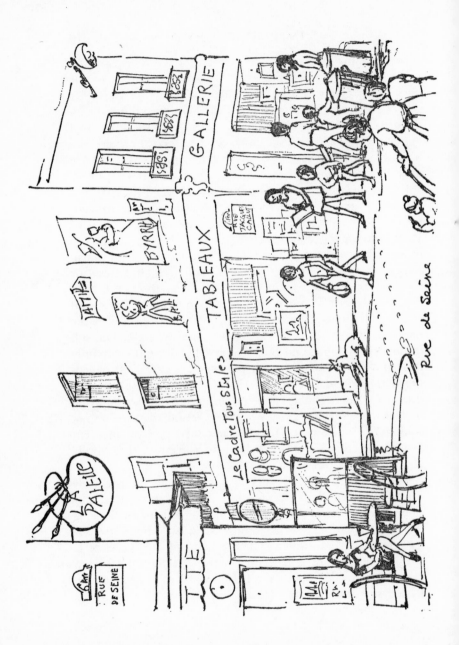

He found life difficult and often sordid and saw no reason to
record this side of it in paintings created for the delight of the
public. So an ugly patch of Paris is transformed by Renoir's
insistence on its few pleasing elements. Up in Montmartre
which he loved so much, Renoir painted, on the spot, the gay
and carefree *Bal Musette* of the *Moulin de la Galette*. Here
too, doubtless, the effect could be sordid, as Toulouse-Lautrec's
drawings prove, but it could also be an absolute enchantment
of flickering shadows, lovely girls, excited and happy, senti-
mental young men and careful chaperones. The dresses of
pink and blue and saffron, patterned with soft violet shadows,
the rhythmic movement and the fascinating air of a mixture
of attractive-looking Bohemians, combine to give an effect of
warmth and light and music, rather repetitive, tinny Paris dance
music serves as a background for conversation. As it is Paris,
they all have the air of dancing differently, to their own particu-
lar tune, and in a minute the scene will have changed and the
girl with the rakish-looking artist will have moved round and
made way for the girl in blue, and be lost in the crowd behind.
The *Moulin de la Galette* is still a colourful place. It still caters
for gay spirits as in the past, but then there was no forced
gaiety, no self-consciousness. It was a normal thing to spend
a Sunday afternoon dancing up on the hill in a country
atmosphere.

Because painters lived and worked in Montmartre, it was
their normal setting and they simply recreated the everyday
life around them.

Van Gogh, when he came first to Paris, was delighted with
its gaiety, and it coincided with a lightening of his rather
sombre early Dutch style. Here he found the colour a revela-
tion, and he shows us the extensive views of the capital from
his studio in the rue Lepic, from the hill of Montmartre—
views which have changed little in their general appeal during
the last seventy years. The great landmarks stood out then as

they do now. He could see Notre Dame, the Panthéon, the Sainte-Chapelle, the Pavilions of the Louvre, at that time recently cleared of the strange conglomeration of artists' dwellings built in its stately courtyards. He saw the roofs of all shapes and colours with their curious massed pink chimneys so characteristic of the Paris sky-line.

Even the people of today are not fundamentally different from their predecessors. The waitresses still have the same air of alertness and the same witty remark on their lips. The workmen still give the impression of hoping for something amusing to happen to break the monotony of their working day. The real inhabitants of the *Butte* still have a healthy country look and are somehow 'villagers', though some of them may be sophisticated enough to make a prosperous livelihood out of catering for tourists.

Toulouse-Lautrec delights in depicting the bohemian inhabitants of Paris, the people of the night clubs, the dance halls and the brothels, with an astringent wit, and before him Degas painted the grace of ballet dancers and the swift gait of a race horse, but it was Utrillo and not an Impressionist who has left the most complete record of the buildings of Paris and more especially of Montmartre. He painted the crumbling walls and peeling façade of the most ordinary buildings and invested them with such a definite personality that they are almost character studies. He makes bricks and stones and mortar live, and even the humblest lane or dullest block of apartments has a fascinating individuality enhanced by his caressing outline and the nervous movement of the often bare trees against sky and architecture.

Later painters such as Matisse, Bonnard and Marquet have left very lovely impressions of Paris and of course contemporaries such as Bernard Buffet, Raoul Dufy and a host of others continue to record its vitality and its timelessness, but the genius of the Impressionists and of Utrillo holds its most colour-

ful and exciting period forever before us, filling us with nostalgia.

But it is not only Paris which these men painted. They have preserved forever the country that existed on the outskirts of the city—the country which was only a short journey away, but is now covered with suburban buildings and factories. Without them, it would be hard to visualise the river at Passy, St Cloud, Meudon and Pontoise as having a country atmosphere, or when passing in the train through the ugly suburb of Asnières, with its huge blocks of flats, to think of it as a retreat for painters.

Though the banks of the Seine further from Paris are still delightful, much that was a Sunday excursion from the capital is now part of the busy city and certainly not the boating and fishing paradise it was, even in the early part of the twentieth century.

II

MONTMARTRE

PIGALLE – THE BUTTE – HAUNTS OF THE IMPRESSIONISTS
AND OF UTRILLO

MONTMARTRE, and more especially the *Butte*—the village on the hill—is regarded today by most people as a kind of 'stage' artists' quarter, exaggeratedly Bohemian, with an exotic night life which all artists are thought to enjoy. Cafés, restaurants and dance halls have mostly been modified to add to this effect and many of them boast of being the resort of members of the Impressionists or of modern movements in art. The Place du Tertre, its main square, is crowded with painters who make lightning paintings of the village and actually sell them, execrable as most of them are. Even so, as I have already said, there remains much that is unspoilable and those places which have been spoilt are at

24

least colourful and gay. Few people would wish to dispense with the tables under the trees shaded by bright umbrellas, nor with the general cheerfulness of people enjoying themselves.

But on Saturdays and Sundays and every day in the summer, the streets are filled with little short of a rabble and huge cars are parked so densely as to obscure the view of the houses. Then it is difficult to find a seat at a café or to obtain a meal at any reasonable price. The only solution is to climb up to the village really early and arrive before the trippers. On the other hand, the lower part of Montmartre, the region of the Boulevard de Clichy and Pigalle, is dull during the daytime and only has glamour at night when the electric signs vie with each other in size and brilliance and the cafés and restaurants are lit up.

The Boulevard de Clichy still has its cabarets and dance halls but they have lost their nineteenth-century appeal, and the non-tourist *chansonniers* can only be fully appreciated by the French-speaking visitor familiar with contemporary events in France. The *Moulin Rouge,* once a favourite haunt of Toulouse-Lautrec and other painters in the nineties, has been rebuilt since it was burnt down in the early part of this century and the silhouette of the windmill is still a landmark of the boulevard, though it is now a cinema. Admittedly the music halls gradually lost their real character as the tourists of the twenties increased in numbers and destroyed their Parisian atmosphere. Nowadays the discerning traveller will almost certainly find his evening entertainment in other quarters of Paris, but he will also want to explore this part of the capital where so many famous painters spent a part of their formative years. He will almost as certainly be assailed by an intense nostalgia for the days before the second world war.

There was once a Roman temple on the hill of Montmartre and, according to tradition, it was also the scene of the martyr-

dom of early Christians including St Denis, the patron saint of France.

For centuries the *Butte* was outside the city limits and until the mid-nineteenth-century the people of Paris used to disport themselves on holidays, in the farms and mills, drinking the local wines and dancing in the barns and gardens. The windmills were a landmark of the village, just as Sacré Coeur is today, and included the *Moulin de la Galette* of Impressionist fame. The slopes were covered with woods and vineyards.

In the seventeenth century, the villagers were such drunkards that the wine shops were prohibited from serving them. No gambling was allowed and even a back door was illegal since criminals could escape through it into the open country when police forced an entrance. This made little or no difference to the state of affairs and, in the eighteenth century, the reputation of the village became even worse; so bad, indeed, that strangers gave it a wide berth for fear of being robbed or even murdered. The village was neglected for over a century and had to depend on the local inhabitants for its livelihood until the painters and writers of the late nineteenth century re-discovered it, profited by its cheap rents and meals, and found inspiration for their work in its old twisting streets, dilapidated cottages and countrified atmosphere. The cafés and taverns came to life again and began to offer a variety of entertainment. They often had gardens behind for dancing. Some of these places were very simple, with rough benches and tables where hard-up artists could sit and talk by the hour over a glass or two of wine.

Other artists established themselves at the foot of the hill, along the Boulevard de Clichy—then called the Grande Rue des Batignolles—and the Place Pigalle, and met to discuss their new outlook on painting at the *Café Guerbois*. When this became too noisy and crowded they moved to the *Nouvelle*

Athènes in the place Pigalle and it was here that Degas painted his *Absinthe Drinkers*. They patronised the Médrano Circus and the *Moulin Rouge* and ascended the hill for the *Moulin de la Galette* and the country taverns. These nineteenth-century artists were by no means the first to be attracted to the village, for the little known eighteenth-century landscape painter Georges Michel had spent most of his time working on the hill and deserves the title of the first of the Montmartre School for his robust and sympathetic paintings which so perfectly caught the atmosphere of mills and quarries and the wild hillside.

Corot was also attracted by the *Butte* for he left paintings of the *Moulin de la Galette* and the rue Vincent, but as far as I know, he did not paint any other pictures there.

The best way to see this whole area of Montmartre is to go on foot from the métro station of Blanche, Pigalle, Anvers or Barbès Rochechouart.

Just by the Place Blanche in the Boulevard de Clichy, is the modern version of the *Moulin Rouge* where the rue Lepic climbs steeply up the hill to the *Butte*, so steeply that you would be well advised to take this on the way down, and first follow the straight and broad boulevard eastwards. Here, in 1886 at number 128, the neo-Impressionists Georges Seurat and Paul Signac worked in adjoining studios. Beyond the Place Pigalle which is now surrounded with night clubs and restaurants, the Boulevard de Clichy becomes the Boulevard Rochechouart and at their meeting stands the famous *Cirque Médrano* where Seurat spent long evenings making studies for his superb *Circus* where the fairy-like equestrienne is lightly poised on one foot on the galloping grey horse. Toulouse-Lautrec worked at the Circus too, and executed a splendid series of drawings from his memories of the Médrano and other circuses which he frequented all his life. Behind the Place Pigalle in what is now the rue Victor Massé, Degas spent a

great many years of his life, working in a large apartment with a studio which was in perpetual disorder. There were easels in every corner, a desk cluttered up with papers, a table covered with lumps of clay, model's clothes and draperies trailing all over the old armchairs, and all sorts of oddments, including a bath tub and a piano which he used in his backgrounds. Piles and piles of canvasses and stacks of frames filled the corners, sketches and half-finished studies were scattered everywhere. The rest of his house was filled with antiques and more especially with a collection of pictures including studies by Manet, Cezanne and Gauguin, some superb engravings and a good collection of Japanese prints.

Puvis de Chavannes lived in the Place Pigalle but his main studio was at Neuilly and he was certainly a very different type from the other artists in the vicinity. He painted vast imposing decorations which were allegorical or historical and is now remembered mainly for the series of murals in the Panthéon. His model for the sad, austere *Ste Geneviève of Paris,* was Susan Valadon, mother of Utrillo.

All along the Boulevard de Clichy a series of roads jerk their way up to the *Butte,* but from the Boulevard Rochechouart short roads lead more or less directly to the Square Willette, the vast terraced garden which slopes up to the Basilica of Sacré Coeur on the summit of the hill. Stone balustrades protect broad, sandy terraces reached by flights of steps and paths bordered with shrubs and shaded by trees and make this garden a delight at any time of day. From the topmost terrace there are miraculous views of Paris which turn into a fabulous spectacle of shimmering light after nightfall. This is also true of the whole of the hill, though not many points cover such an extensive view as this. As you ascend the terraces, you cannot but be impressed by the vast, dramatic bulk of shining white domes and turrets which make up the mosque-like appearance of Sacré Coeur. Extremely ugly as a piece of archi-

tecture, it has a certain attraction as though it were the main set piece of an exhibition or the winning sandcastle made of the powdered white shells of a beach in Ireland, and it is a landmark of Paris, decorating the horizon with blousy curves in complete contrast to the austere and lovely lines of the Eiffel Tower.

The National Assembly of 1873 ordered this monstrosity to be built, in expiation of the sins of the Commune, on a site which witnessed excesses on both sides during the fighting of 1871.

Beside this huge edifice stands the little church of St Pierre, all that remains of the Benedictine Abbey of Montemartre, on the site of a basilica dedicated to St Denis. The building was erected during the last threequarters of the twelfth century, but the vault of the nave was rebuilt in the fifteenth century and the aisle vaults were added at the beginning of the twentieth century. The original apse has been almost entirely rebuilt, but there are four ancient columns, possibly from the Roman temple, which have been incorporated in it. Modern stained glass of excellent design and colour was added to the windows in the side aisles in 1953.

The cloisters and graveyard of the convent, with the Stations of the Cross, are now surrounded by a garden in front of the church. To the north the foundations of a Roman temple have been unearthed. To the left, the picturesque Place du Tertre occupies a piece of land given by the convent and planted with trees in 1635. Familiar all over the world from countless paintings, this picturesque square will also be remembered as one of the settings for Puccini's *La Bohème*, and indeed the square has hardly changed since that time. To me it is always at its most beautiful in the quiet of a winter's day of sunshine when the sharply defined dark branches of the trees starkly rising out of the gravel, cast delicately drawn shadows over the peeling grey and yellow frontages of the houses.

The network of roads around the Place du Tertre is best explored in sections for, quite apart from their attractive rural aspect, they have close associations with famous painters. Directly behind the north side of the square runs the rue St Rustique, an old street, still completely unspoilt and, running nearly parallel to it, the rue Norvins, still very attractive but full of cabarets and restaurants, is typical of the quarter. A right turn where the rue Norvins and the rue Rustique come together leads to the tiny vineyard in the rue des Saules, the only one remaining of those which used to produce the wine of Montmartre. Elaborate ceremonies are still enacted when the grapes are gathered and pressed. Close to the vineyard you will find a country cottage with tables set out under the trees in front of it—the famous *Lapin Agile*—where painters and intellectuals used to gather, under the ministrations of the picturesque figure of Frédé, an intelligent old man, with a long white beard, who improvised songs to the accompaniment of a guitar. Those days are long past, but his son Paulo carried on the tradition after the war, with a witty *chansonnier* programme though now it is, I believe, restricted to the singing of rather old-fashioned and well-known songs to tourists who visit the inn in numbers. For the price of a glass of champagne they can sit in the raftered room and conjure up memories of earlier days.

Several interesting picturesque roads lead off from the rue des Saules. The first on the right from the rue St Rustique, is the rue Cortot where, in 1876, Renoir moved from the rue St Georges south of the Place Pigalle. He came partly because of the countrified atmosphere and the delightful garden where he could work out-of-doors undisturbed, but mainly because he intended to paint his ambitious picture of the *Moulin de la Galette*, and he wanted to be within easy reach of his subject, a short distance away at the corner of the rue Lepic and rue Girardon.

This old mill which has now been restored, is the last remaining windmill in the *Butte* and dates back to the seventeenth century, but was erected in more or less its present position in the eighteenth century. It belonged to the Debrays who owned the farm nearby. A descendant of the original owners had the enterprise to turn it into a kind of wine garden where he sold cakes—*galettes*. He also hired fiddlers and led dances himself in which the local populace used to join. It soon became a well-known place of amusement, although perhaps a rather shady one during the week; but the dances held there on Sundays in the open air were more or less respectable and presented just the kind of scene that Renoir loved to paint. The garden took on the air of a *fête champêtre*, a modern version of the magical scenes painted by Watteau which Renoir had so often copied onto porcelain when he was scraping a living by working in a factory.

Renoir insisted on carrying out the whole composition on the spot and he called in friends and models to pose for him, yet he manages to preserve an effect of dropping in on the scene, which is wholly delightful.

One of the young women, Jeanne, in the striped silk dress, was Renoir's favourite model and he painted her again in *The Swing*, in a blue and white dress with bows and lace and frills, revelling in the warmth of a sunlit garden setting. The garden was indeed Renoir's own in the rue Cortot, full of lovely old trees and flowers. Even the street had its own peculiar charm, for all its houses were dilapidated; there was practically no pavement and it was nothing more than a steep unlighted lane running down to the rue des Saules.

Utrillo lived in this street too, with his mother who acted as his manager, his guardian and his nurse, encouraging him to paint, which was the only thing that kept him from complete breakdown. She tried to keep him from the bars where he drank himself sodden whenever he could, but despite her

B

vigilance he was always being brought back to the house in a state of collapse or manhandled by the police.

Degas, too, had a studio here for a time, but then he lived in Passy so was only there in the daytime.

To the left of the rue des Saules and opposite the rue Cortot, runs the rue de l'Abreuvoir, so called because cattle used to drink here at a fountain. It leads to the rue Girardon and to the Allée des Brouillards, a small area scarcely visited by tourists and without the obvious attractions of bars or cafés. Here you will find all that it left of the Château des Brouillards standing on a small patch of lawn and divided by a path from a long curve of *pavillons* in one of which Renoir lived for a time. The Allée des Brouillards is still a country lane bordered with trees, through which can now be seen the white domes of Sacré Coeur. A little to the north, in the rue St Vincent, you will find the minute cemetery in which Utrillo lies buried.

The Avenue Junot sweeps in a deep 'U' from the rue Girardon and comes out again opposite the rue Norvins. Built on the *marais*—a stretch of wasteland at one time covered with shacks—it is a comparatively modern street and not very attractive, but it has become fashionable and is now occupied by successful writers, artists and actors. It was here that Utrillo bought a patch of land and built a house when he became rich through the increasing sales of his pictures. It obviously did not suit him as well as his studio in the rue Cortot, which he still continued to use.

In the Musée du Vieux Montmartre, at the corner of the rue St Vincent and the rue Mont-Cenis, you will find a collection of porcelain made during the eighteenth century in a pottery at the junction of the rue Marcadet and the rue Mont-Cenis. Later this same building was lived in by Renoir, Utrillo, Dufy and other painters of note. Beyond this house, to the north, the rue Poteau runs into the rue Mont-Cenis at the Place Jules Joffrin. It was at 3 rue du Poteau that the puny little

Maurice was born in 1883 to Maria—later to be called 'Suzanne'—Valadon. Maurice was illegitimate, like his mother; she gave him the surname of Utrillo after the Spaniard, Miguel Utrillo y Mollins, who was probably not his father anyway.

The church of Notre Dame de Clignancourt stands in the Place Jules Joffrin and Maurice often used to attend Mass here as a child with his grandmother; in fact he developed a great love for this very ordinary, even ugly, modern church, and did a painting of it.

When his mother moved to the rue Tourlaque, Maurice remained at the old house with his grandmother for a short while before the pair joined her there. The child was certainly brought up in a bohemian atmosphere and met the foremost artists of the time when he was still young, for his mother's lover was Toulouse-Lautrec and she was advised and encouraged in her painting by both Renoir and Degas.

Lautrec's first studio was in the rue Caulaincourt at the corner of the rue Tourlaque. He used this studio to work in, and lived for some time with a doctor friend in the rue Fontaine, off the Place Blanche. This studio had all the attributes of a bohemian painter's workshop. Like Degas', it was untidy, not particularly clean and had a strange assortment of furniture. Everything was in a muddle, with drawings, books and papers thrown all over the place. Nevertheless it was an amusing room, full of all the strange things which, from time to time, he collected. He loved Persian pottery, Japanese prints and his friends' paintings, but he also had a collection of bird cages and, of the utmost importance to him, every possible kind of drink. He entertained eccentrically, always liking to try out now recipes for cocktails and for main dishes. Once he invited friends for an evening's entertainment, to eat kangaroo at the house of a photographer in the Place Pigalle—the dish was in fact only lamb but dressed up to be something rather exotic. He hated anyone to drink water, so he put goldfish into

the carafes. He also amused himself by designing the menu
cards delightfully.

When he was thirty-three, Lautrec moved to the neighbour-
ing Avenue Frochot, a little countrified road with villas and
gardens on either side. He worked in this studio, but he lived
with his mother who took an apartment in a nearby street.
She had come to Paris to be near her son, whose health was

threatening to give way and who was already becoming more
and more unsteady on his crippled legs.

At the bottom of the rue Caulaincourt there used to be a
large, wild garden owned by Père Forest, a friend of the
painter's, and it was in this garden that Lautrec painted many
of his portraits. The patron and friend of the Impressionists,
Coquiot, tells us how the painter's models were drawn mostly
from the harlots of the Boulevard de Clichy or the Place
Blanche. They used to sit for him in the open air so that he
could analyse their features under the brilliant daylight. Not
only did Lautrec work here, but he was always delighted to

receive his friends and to give them one of his famous cock-tails. He wasted no time in installing a bar in the garden, where he often entertained lavishly, turning it into a kind of fair-ground. Few gatherings were more lively or uninhibited than these, when '*monsieur Henri await invité*'.

The region to the west of Lautrec's studio is occupied by the important cemetery of Montmartre, where Degas lies buried and the sentimental eighteenth-century painter Greuze, as well as many other painters, writers, actors and musicians and the beautiful Madame Récamier, whose portrait David painted.

The rue Tourlaque leads to the rue Lepic and the house—number 54—where Van Gogh came to stay with his brother Theo in 1886. This attractive, meandering street runs straight uphill from the Place Blanche and the *Moulin Rouge*, before reaching the rue des Abbesses and then curves away to the west in a swiftly rising crescent. When it reaches the rue Tourlaque it turns right and, in the angle, stands the tall apartment house where Van Gogh painted so many of his pictures of Paris. Beyond the house the road continues uphill to the *Moulin de la Galette*, but graded in easy stages by Napoleon III so that carriages could make their way to the *Butte* without too much difficulty.

Van Gogh was fascinated by the colour and life of Paris and his brother's apartment was in a perfect position for him to see, not only the pulsing life of the city, but the bohemian life of the village. From his third-storey window he could look right over Paris and down to the lower part of the rue Lepic which is now a busy shopping street and market. The prospect over the city enchanted him, for he loved the roofs of every colour and shape. In his view of the capital he seems to unroll the whole pageant of Paris as, with his sure touch, he shows us the buildings along the river and pours light with equal intens-ity onto the side of a house, onto an ordinary roof or a *pavillon* of the Louvre.

From below the *Butte*, Van Gogh painted the wonderful skyline of windmills, the plaster quarries and the vineyards. The northern arm of the rue Lepic leads into the rue Ravignan and the Place Emile Goudeau. At some point at the beginning of the twentieth century, a strange ramshackle collection of buildings, known as the *Bateau Lavoir*, was made out of planks of wood crazily knocked together. As it was shaped like a boat and swayed in the wind, it was compared to the laundry boats on the river—*'les bateaux lavoirs'*—hence its name. Here, from time to time, most of the famous names of the early twentieth century lived and worked or at least met together to discuss painting. Here Picasso, Max Jacob and Modigliani worked and here Cubism was born. During the first world war, the *Bateau Lavoir* became more and more dilapidated and, in the twenties, artists left the studios and many of them deserted Montmartre altogether to abandon village life for the more sophisticated atmosphere of the Montparnasse quarter of Paris.

If you walk downhill from the Place Emile Goudeau, you will arrive at the Place des Abbesses which is, incidentally, served by a métro station. In this quarter of the *Butte* are some excellent restaurants where it is particularly pleasant to lunch on Sundays when the market is in full movement and flower stalls flank the ugly brick church of St John the Baptist, another church which Utrillo favoured.

Alternatively it is entertaining to go to the Marché aux Puces at Porte de Clignancourt, to the north of the village and easily reached from the Métro Clignancourt. A rather brash modern market is reached before gaining the acres of wooden shelters where antiques are displayed or often just heaped together on the stalls which are divided by pathways. Even now you might be lucky and find something good which is also cheap, but most of the cheap things are mere junk and the genuine antiques very expensive. Nevertheless there is

always a lively crowd here and the stall-holders often have amusing and witty observations to make.

It is easy enough to get from the market to the *Butte* and then have lunch in the Abbesses and rue Lepic area which is away from the prices and 'chichi' of the Place du Tertre. You are not likely to find many tourists here, and if you pick your restaurant, you will eat as well as anywhere in Paris, though in the setting of brown varnished panelling or dazzling strip lighting of a popular or bourgeois establishment.

From the Abbesses you can roam the *Butte* or pick your way along the wandering route of the rue Lepic past the *Moulin de la Galette* and down to the Place Blanche.

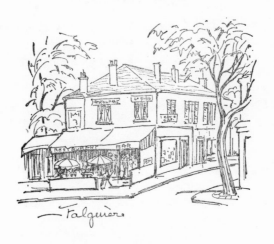

Falguière

III

MONTPARNASSE

Plaisance – Petit Montrouge – Falguière – La Ruche

Between the First and Second World Wars, Montparnasse became the Mecca of painters, actors, writers and poets and those aspiring to the creative arts from all over the world. Every painter in Europe had heard of the _Jockey_ and the cafés of the _Dome_ and the _Rotonde_—of the Boulevard Raspail and the Boulevard Montparnasse. Many painters, already famous or later to become so, had for long been working there; whilst the Impressionists were on the _Butte_.

There is nothing of the atmosphere of a village in Montparnasse and none of the obvious picturesque qualities so evident in Montmartre, but there were, and still are, spaciousness and a monumental layout. Undoubtedly the bulk of the studios and apartments were rather more comfortable and sanitary than some of the near-hovels in which the poorer

painters of Montmartre lived. Nevertheless there were many attractive cottage-studios with courtyards and even little gardens, and whole terraces of cottages, more especially to the south, away from the cosmopolitan hub where the Boulevard du Montparnasse and the Boulevard Raspail meet.

In the nineteenth century there was already a *Café de la Rotonde* and the proprietor granted credit to his hard-up clients who gave the place its bohemian atmosphere. Many of these artists achieved success and continued to patronise the café which had befriended them, so it acquired a much more prosperous air and became famous as a centre for artists of repute. In the years before the First World War, Lenin, Trotsky and other Russians used to meet here. For a time, between the wars, the *Rotonde* was especially favoured by South Americans, Rumanians and other Latins, whilst the *Dome* opposite was popular with the Anglo-Saxons and the Scandinavians with a good admixture of Slavs who patronised both sides of the Boulevard. Then, to deal with the increasing tourist crowds who came to rub shoulders with the famous, a larger café—the *Coupole*—was opened, with brighter lights and broader terraces. The *Palette* followed and a host of smaller ones. Now several of these have closed down and, although the specific artistic and bohemian atmosphere has diminished, the *Rotonde* and the *Dome* are still very cheerful, very full and very brightly lit. Here you may, even now, spend an evening on the crowded terrace for the price—and quite a high one—of a drink.

There are a number of night clubs in the little streets off the Boulevard Raspail and also taverns serving national specialities to a Swedish, Norwegian, Danish and Russian *clientèle*. *Dominique*'s produces delectable Russian dishes, but it is no longer the place to stop for a cheap quick snack and a Vodka.

The popularity of Montparnasse as an artist's quarter was beginning to wane before that time, and the narrow, pictur-

esque streets of another quarter were slowly being explored. Painters migrated to the *Sixième*, the Quartier St Germain-des-Prés, which has also become a tourist show place, though it does keep the students' character because the Ecole des Beaux Arts is situated right in its centre.

At the very beginning of the twentieth century, an 'advanced' poet, Paul Fort, decided to make his centre the *Closerie des Lilas* at the corner of the Boulevard du Montparnasse and the Boulevard St Michel; he collected around him a crowd of painters and writers. Among these he could count such names as Modigliani, Picasso, André Derain and the poet Apollinaire who had a great love of painting and more especially of anything which showed imagination or unusual vision. He was an ardent supporter of the Cubists and, indeed, of all serious new movements in art. Lenin and Trotsky were also regular customers.

By 1912, many painters had already left Montmartre and Picasso was installed in a studio in the rue Schoelcher at the south-east corner of the Cemetery of Montparnasse. Academies of Art sprung up all over the quarter. Matisse ran one in the rue de Sèvres, but soon moved it to the Boulevard des Invalides, whilst Van Dongen opened another establishment of this kind on the Boulevard du Montparnasse. The Academy Julian was, for a while, in Montparnasse, though it is now in the rue du Dragon, and the Académie Suisse on the Quai des Orfèvres, which had as pupils—or rather, students, as no instruction was given—Delacroix, Manet, Courbet, Pissarro, Monet and Cézanne, was finally sold to an Italian model who installed it, in 1870, at the corner of the rue de la Grande Chaumière, (between the rue Notre Dame des Champs and the Boulevard Montparnasse) where it is still possible to draw from life today.

Gauguin came here to paint, when he was still a stockbroker and he later lived in a number of studios in Montparnasse, the most exotic one being in the rue Vercingétorix which he

occupied on his return from Tahiti in 1893. This studio was
considered really alarming and sinister. The walls were deep
yellow and decorated with all sorts of strangely coloured
hatchets and boomerangs. The doors and windows were painted
with grotesque Tahitian scenes, and shelves were heaped with
shells and crystals. Gauguin's pictures were on show and a
tame monkey leapt around the room. The painter was always
dressed in a most unusual manner and although he un-
doubtedly spent evenings discussing, in a highly intelligent way,
his theories on art with the most distinguished talkers, to the
average person, he appeared to be a blatant and preposterous
poseur. He went about in a blue Russian shirt embroidered in
yellow and green. His blue frock coat had mother-of-pearl
buttons and he wore fawn trousers. A bright blue ribbon was
tied round his huge felt hat. He was shod in carved and painted
Breton clogs and carried an obscenely-decorated stick in his
white-gloved hand. He was often accompanied by his monkey
and by a brilliantly coloured parakeet; also sometimes by his
mistress, a half-caste Javanese who acted as hostess at his
studio parties.

Vollard tells the strange story of this girl from Java, in his
Souvenirs d'un Marchand de Tableaux. It seems that an Opera
singer, Madame Nina Pack, expressed a desire for a negress
as a servant. Some months later a policeman brought to her
door a little half-caste he had found wandering in the street,
with a placard round her neck, bearing the words : 'Madame
Nina Pack, rue de La Rochefoucauld, à Paris. A present from
Java.' Her employer was delighted and amused, and gave her
the name of Anna. It seems she was not satisfactory, however,
for she was soon dismissed and went to Vollard whom she had
seen at Madame Pack's, and asked him to find her work. He
decided that she was just the type to appeal to Gauguin as a
model, and so her association with the painter began. He said
she provided the right amount of exotic atmosphere particu-

larly for his Wednesday evenings, the regular gathering of friends and acquaintances invited to pay homage to Gauguin. It is certain that he attracted a most interesting group of visitors to these parties where he presided like an Oriental prince, but most of them were of sufficient distinction to be more impressed by Gauguin's brilliant intelligence than by any exotic setting.

Gauguin was indeed very much of a *poseur* at this time and was childishly excited at being in Paris with money to spend. But perhaps an equally amusing figure was Henri Rousseau, the Customs official in a minor position in the Octroi encircling Paris. He was so insignificant-looking that even when his paintings were recognised, he was referred to as the *Douanier*, and has remained Douanier Rousseau ever since. When he qualified for his pension, he retired to become a professional painter. He lived in the rue Perrée, out of the rue Vercingétorix which lies just beyond the Avenue du Maine in the Plaisance quarter of Montmartre. Apart from Gauguin's studio there was nothing exotic or picturesque about this district and, in any case, Rousseau was already there when Gauguin arrived. It was not then his immediate surroundings which gave him the exotic subjects for his pictures, nor did he have to travel to the South Seas, like Gauguin, to find his subject matter. Most probably he studied the exotic plants and animals in the Jardin des Plantes, not far from his house.

Whilst at the Octroi he was already painting portraits and landscapes and, after he had left the service, his memory of it provided him with subject matter, for he painted pictures of the Customs House and of the country round about.

At first Rousseau was not taken seriously as a painter. *Le Douanier* was an extraordinary little man without much education and without any interests except painting and music. He was forever boasting what a great painter he was, but he never succeeded in making enough money from his art to live on,

and used to give lessons in drawing, painting and music in his studio. A plaque on his door read :

COURS DE DICTION
MUSIQUE
PEINTURE ET SOLFÈGE.

He supplemented his small income by painting portraits of the local tradesmen and displaying his landscape paintings in a little paper shop which his wife looked after; he also took a job as a drawing master in an elementary school. The children must all have loved this strange little man, who had a never-ending fund of marvellous and fantastic stories which he related as personal experiences.

In 1890, the Douanier began to mix with the great personalities of the time, and it is his connection with these people which gives him a place in the age of Impressionism, although he himself really belongs, in style, to the twentieth century.

He met Gauguin, Redon and Gustave Coquiot, who was to write so many romanticised lives of the Impressionists; Seurat, Pissarro and he used to hold evening gatherings which he pretentiously called '*soirées artistiques*' He sent out pompous invitations to his studio over the plasterer's shop. To do him justice, the Douanier arranged these evenings with consummate care, having an elaborate musical entertainment complete with programme. The guests were very mixed, for he invited his pupils' parents, who were the local tradesmen, some of his old Octroi friends, and a new set whom he was collecting from the art world of Paris. Wilenski tells us that the concert began with the Marseillaise played by a full orchestra !

In many ways the Douanier was a pompous man, but Vollard, the picture dealer, says in his *Memoirs* : 'Whether one liked his painting or not, one could not help liking the man, who was complacency itself.'

It was in 1891 that Rousseau first began to paint his strange

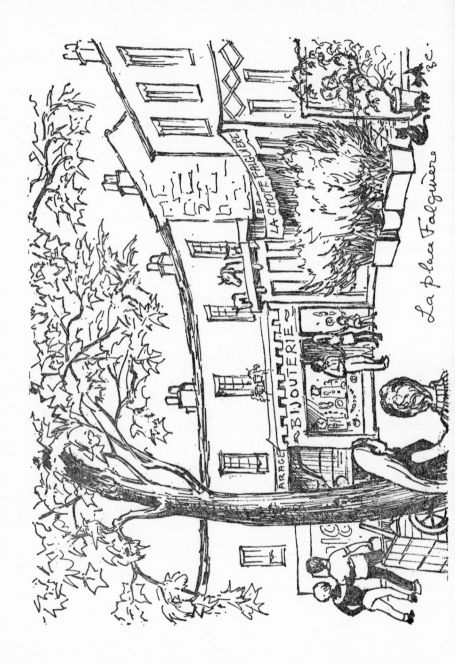

La place Falguière

exotic jungle scene and it was then that he produced the wonderful painting *A Storm in the Jungle*. It has the quality of a tapestry in its decorative completeness. The texture of the tiger's pelt is superbly suggested, and the movement of the animal has obviously been studied with very great care. All varieties of plant forms were fascinating to Rousseau, who arranged them to make a beautiful pattern at the same time enveloping the whole picture in atmosphere. Again and again the Douanier uses the jungle background; sometimes with wild animals, often with little furry monkeys, surprised-looking lions and tigers and strange birds.

In the early years of the twentieth century, Rousseau's ambition was fulfilled. He was now over sixty but he was also the centre of the avant-garde painters and writers in Paris, and recognised by the whole of the intellectual world. He accepted this acclaim as his due but it did not turn him into a sophisticated painter. He always kept the astonished vision of a child, and although he had a dealer who tried to sell his works, he never received more than very small sums for them during his lifetime.

In 1909, the Douanier was involved in an unfortunate bank swindle, probably due to his easy gullibility. He had no idea that he was committing a crime, and although he was found guilty and sentenced to imprisonment, he never served his term. He pleaded that he was a simple man who had never had a bank account nor any dealings with money, and did not know that there was anything criminal in his action. His counsel produced the Press cuttings which Rousseau had carefully kept although they all presented him as a rather queer slightly crazy amateur. Some of his jungle pictures were also shown in court, including the monkeys in the forest. The jury immediately assumed that he was simple-minded, and he was given the benefit of the First Offenders Act. Needless to say the Douanier himself was very much upset at being referred to as

a simpleton, though he was greatly relieved at his acquittal, and thanked the Judge in the following terms: 'I thank you very much, Monsieur le Président. I will paint a portrait of your wife.'

Although he had many important artist friends, most of them were away from Paris when he died, and so only a few people were present at his funeral. When his great friend, the poet Apollinaire, returned to Paris, he saw that a suitable tombstone was erected on which he wrote an epitaph.

To the north of the Boulevard du Montparnasse, in the rue Notre-Dame-des-Champs, Renoir worked for some time when he returned to Paris after the disturbance of the Commune. Whistler had a studio in the same street and, at the end of the nineteenth century he established his Academy of Painting in a small road leading off it, now called the rue Jules Chaplain. At one time he also shared a studio with Rodin in the Boulevard itself; indeed it is right in the midst of the cosmopolitan cafés that Rodin's statue of Balzac stands. It was commissioned by the *Société des gens de Lettres* in 1898. However, the dignitaries of this erudite society disagreed as to its suitability, and it was rejected and not set up on its present site until 1939.

Although, as stated earlier, the cafés at the Carrefour Raspail and Montparnasse were the centre for international intellectuals and bohemians, there were also other important meeting places. About three-quarters of a mile further east, the *Closerie des Lilas* was in a strategic position at the meeting point of the Quartier Latin, the Quartier St Germain-des-Prés and the Quartier Montparnasse. Originally a *guingette* with a big, tree-shaped garden in what was then a rather lonely country road, it was a coach stop on the way to Orléans. Its rustic setting attracted writers and painters who used it as a sort of club.

The Closerie was by no means the only place of entertainment, for the whole boulevard gave access to a number of

cabarets and *bals champêtres*. Close by was the famous *Grande Chaumière*, opened by the Englishman, Tickson, in 1783, and famous for its very daring dances such as the can-can. It consisted originally of a few small colour-washed huts with thatched roofs grouped together in a garden—hence the name. As the place became popular, so the rough buildings made way for a two-storey house, whilst the gardens were laid out with arbours and amusement booths. In 1855, the proprietor, le Père Lahire, was obliged to close down because of the competition of other places of entertainment and his *clientèle* was taken over by the *Closerie*. There is now no trace of the establishment nor of the gardens save, I believe, an old acacia tree. The *Closerie*, on the other hand, still has a terrace and trees and the general atmosphere of a garden, though a very small one compared with the original vast domains. Nevertheless it retains its aura of the artist and writer though it is no longer cheap and even a careful meal or drinks could be a strain on the limited funds of the currency-short foreigner.

As inevitably happens when a district develops into a tourist attraction, it becomes expensive and begins to lose its original character, whilst the younger, serious painters find a cheaper local centre elsewhere. So gradually artists looked for studios and cafés away from the hub of the Boulevard and migrated either north to the *Sixième Arrondissment* or further south on either side of the railway line running south-west from the Gare Montparnasse.

You will find a maze of small streets and passages with studio cottages and apartments off the Avenue du Maine which runs down to Alésia, a district now very much favoured by painters and referred to as the Petit-Montrouge, but which retains its local atmosphere without being troubled by sight-seers. You will find low, terraced whitewashed cottages with coloured shutters, lining streets planted with acacias, whilst small 'village' shops occupy the ground floors, displaying their

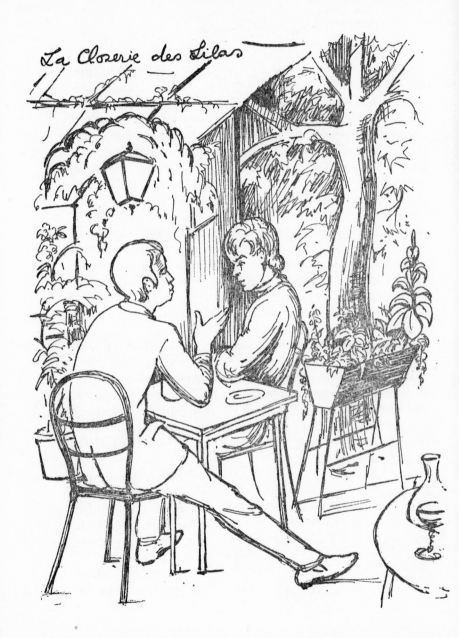

La Closerie des Lilas

goods along the pavement. You will also find ugly blocks of
modern apartments interspersed with a few cottages in streets
of no distinction. Most of the painters live in studios in or off
the rue du Moulin Vert. Here there are a number of reason-
ably priced restaurants, but some luxury establishments have
also begun to appear lately. Only a few years ago the *Restaur-
ant du Moulin Vert* was a little countrified inn in a leafy
garden where chicken scratched away in the gravel whilst,
on summer evenings, customers sat under the trees and were
served with cheap and excellent, though simple, food. It is now
a very attractive restaurant entirely re-arranged in the style of a
sophisticated country inn, serving ambitious food at ambitious
prices, in a setting which has no place for scratching chicken,
nor for the poverty-stricken artist. It has been re-named the
Clos du Moulin.

Further east, but still reached quickly from the eastern end
of the rue d'Alésia, lies the fascinating park of Montsouris,
hardly ever visited by foreigners, even though, since the build-
ing of the Cité Universitaire directly to the south, it has become
better known. On weekdays it is practically empty and you
can enjoy a stroll through its lawns and its exotic trees in
solitude. The north-east corner, where there is a restaurant, is
by a lake, and the Bardo at the southern end, now used as an
observatory, is a reproduction of the Bey's palace at Tunis
which was originally made for the exhibition of 1867. Georges
Braque appreciated the remote peacefulness of this quarter
for he had a studio in the rue Douanier, a narrow passage off
the western side of the park.

The more attractive sections of the Falguière district, on the
western side of the Montparnasse railway line, are accessible
with difficulty except by bus. The rue Falguière runs south
off the rue Vaugirard and, in the adjoining cobbled and rather
dilapidated streets, the many sculptor's and painter's studios
are becoming increasingly hard to rent because of the shortage

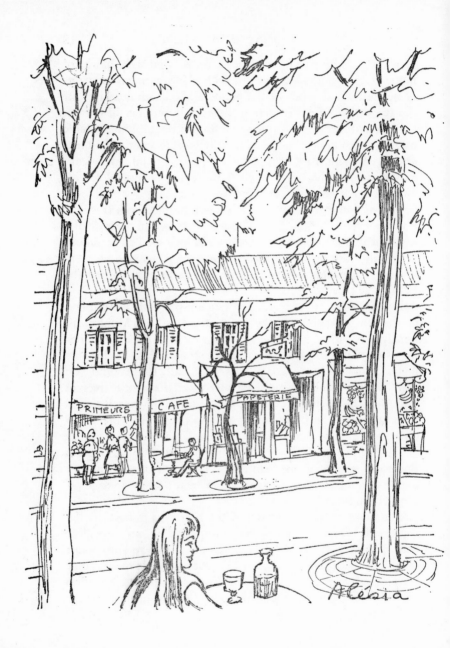

of accommodation in Paris. This is still definitely a shabby
district, but it is full of fascinating corners, in particular the
Place Falguière—an oval of cottages, colourful cafés and
restaurants shaded by trees. Apart from the appeal of pictur-
esque shabbiness, this quarter is only of interest to a painter
wanting to work in Paris, for here, as in Petit-Montrouge, there
are amusing bohemian circles, but to join them is not as easy as
it is in the more obvious artists' quarters, for you need to be
introduced or slowly assimilated.

Further south, but west of the Porte de Vanves and the
Abattoirs is a still shabbier district, off the rue de Dantzig,
where ugly buildings, adapted from storehouses and workshops,
are now rather down-at-heel studios, but some of the odd
passages and courts can be quite attractive. The Passage de
Dantzig branches off from the main road and is largely taken
up by decrepit studios and workshops, many almost too dilapi-
dated to be attractive, and obviously leaking and bitterly cold
in winter. One building will assuredly hold your attention
though—the extraordinary beehive of studios called *La Ruche*.
An imposing, rusted iron gateway in the art nouveau manner,
overgrown with creeper and flanked by brick pillars topped
with urns, leads into a wilderness of garden which encircles
this curious establishment, and which may possibly have been
built from material of the dismantled 1900 exhibition. The
colossal female figures supporting the entrance certainly
suggests this and so does the curious lantern and finial which
caps the wedge-shaped sections. Incredibly dilapidated, it has
been threatened more than once with demolition, but has now
become such a landmark that there are hopes that it will be
preserved. Picasso, Chagall, Soutine, Léger, Modigliani and
Apollinaire all lived there for a time and, when funds were
low, Léger and a friend used to sing and play in the streets, to
pay for food, which consisted mainly of bread and herrings.
When it was first opened in 1902, exhibitions were held and

plays tried out. Many foreigners of influence came to stay, to
encourage young artists, and in fact it was called the Villa
Médicis—a City of Culture. It still houses a colony of artists
guarded by a large brown dog, a red setter who stands mourn-
fully at the entrance but makes no attempt to prevent anyone
from wandering into the mouldering garden.

IV

THE LEFT BANK

THE LATIN QUARTER – ST GERMAIN-DES-PRÉS

THE Latin Quarter, which covers a vast area of the Left
Bank, is not exactly an artists' quarter in the same sense
as Montmartre and Montparnasse are. However painters
live scattered all over this district since there are a large number
of studios, and the smaller streets and squares are not only
picturesque but are inhabited by amusing characters and
students of all types and nationalities. If we add St Germain-
des-Prés with the Ecole des Beaux Arts, its art sudents and its
international appeal to tourists, and the *Septième Arrondisse-
ment* to the west, we have a region in which most foreign
painters would choose to spend their time.

In the Middle Ages, Latin really was the common language
used by students in Europe. This quarter occupies the
Cinquième and much of the *Sixième Arrondissements* and
its main artery is the Boulevard St Michel—a street which is

always lively and colourful, thronged with students and tourists at all times of the day and night. To the west stretch the lovely Luxembourg Gardens and a labyrinth of streets to explore; to the east, the Sorbonne, the Panthéon, the superb Cluny museum and mansion, the Val de Grâce and the remains of the Roman arenas. To the east lie the exotic Jardins des Plantes and, on either side of the northern end and bounded by the quays of the Seine are some of the most attractive old streets in the whole of Paris. Add to this, the fact that Notre Dame, the Ile St Louis and the Louvre are just across the river, and it is obvious that the Left Bank is the most convenient as well as the most attractive part of the city in which the painter or student of the arts can stay. There are still simple hotels which are comparatively inexpensive, and facilities for eating cheaply. Also, trains from the Luxembourg station, just by the Gardens, take you quickly and cheaply on the Ligne de Seaux into the miraculous countryside of the Vallée de Chevreuse.

The historically-minded may want to begin an exploration of the Latin Quarter from the Arenas of Lutétia but, in summer at any rate, the Luxembourg Gardens offer a much more attractive starting point. Although these gardens are very small, they give the impression of size by the use of skilful layout and the disposition of huge trees. It is one of the few Italian Gardens left in Paris, for most of the others disappeared in favour of the English garden which became so popular in the eighteenth century.

The land was bought in the spring of 1612 by Marie de Médicis from the Duc de Luxembourg, and the gardens were laid out a year later on the site of a Roman camp and of a thirteenth-century monastery. By the eighteenth century they had become a popular promenade for writers and painters, including Watteau, who used to stroll about amongst some sixty statues of the Queens of France and other celebrities.

Most of them are of little artistic value, but they do give variety, contrast with the foliage and grass and fit in well with the general architectural scheme of the Palace. Marie de Médicis had the building designed by de Brosse in a style reminiscent of the Pitti Palace in Florence to remind her of her childhood home. The main part of the garden is laid out to form a vista for the principal façade, and there is an uninterrupted view over the length of the gardens and along the Avenue de l'Observatoire, which is itself laid out with lawns, to the Observatory.

The large central pool is a great attraction, especially for children who can hire sailing boats by the hour. In other parts of the garden there are Punch and Judy shows, bowling alleys and strips of bare uneven ground where young people play rough-and-ready croquet and football among regiments of tall, slender trees. To the east of the Palace, the 'Medici' fountain, also by de Brosse, has a rather forlorn air despite its good carving, but the flower gardens to the west are entirely delightful and tended with great care. There is a school of arboriculture, and even apiaries, on the corner looking onto the rue d'Assas. It is indeed one of the most lovely gardens in Paris and benefits by being full of lively students in colourful dress, studying or involved in endless discussions. There is plenty of room for everyone, the very old, the very young, the locals, the students and foreigners who stroll about or sit on the benches or on elegant little iron chairs.

The Palace had several owners after Marie de Médicis and was used for the first time as the Senate House during the Third Republic. The Rubens paintings are now in the Louvre, but the Delacroix murals can be seen in the Library. The Orangerie once housed a rather dreary collection of modern art which was dispersed when the Musée de l'Art Moderne was opened.

South-west of the Luxembourg lies the rue Notre-Dame-des-Champs and the district round Montparnasse described in the

last chapter, but from the north-eastern gate, the rue Bonaparte leads directly to St-Germain-des-Prés and the noisy jostling hub of the *Sixième* where the cafés overflow onto the pavements and onto the roadways in the summer and are crowded even in winter. This is an exciting quarter of endless variety with beautiful old houses, odd passageways and minute squares full of interest for the painter.

Familiarity with the huge bulk and incongruous towers of the church of St Sulpice, far from breeding contempt, induces a kind of affectionate acceptance, and the vast size of the Square in which it stands off the rue Bonaparte is a relief after the narrow pavements and constriction of the nearby streets. Built in 1646, it was lack of funds that prevented it from being completed. The towers, though roughly similar, are of a different height, which is not surprising since each was designed by a different architect, and the whole effect is overpowering, but it is worth going inside to look at the fine frescoes by Delacroix.

In complete contrast to the architecturally unsatisfactory St Sulpice, the church of St Germain-des-Prés stands simple and austere, its grey stone tower rising up in magnificent proportions against the sky. Most of the present building is eleventh- and twelfth-century, but the interior has been completely changed by repeated renovations. However there are still details of great interest such as the marble Merovingian columns of Childebert's time and the Romanesque capitals in the choir with carvings of lions, harpies, foliage and birds as well as human figures. There is also a very lovely marble statue of Our Lady of Consolation, dating from the mid-fourteenth century. In the Middle Ages, this was the abbey church of a monastery outside the walls of Paris. Fabulously wealthy, it was a city in itself, enclosed by a wall and almost independent of any outside authority, although it was by royal decree that the Pré aux Clercs—now the rue du Pré aux Clercs—was granted to the young monks as a recreation ground.

In the narrow church garden shaded by trees, which was once the abbey cemetery and now flanks the Boulevard St Germain, stands a statue of Bernard Palissy, the famous sixteenth-century potter whose workshop is believed to have been in the rue du Dragon, off the rue de Rennes. The even more interesting part of the garden is the little square on the opposite side in the rue de l'Abbaye, for here are remains of the carvings from the former Lady Chapel built in the first half of the thirteenth century. Even covered with creepers and ivy as they are, they combine perfectly with the very modern piece of sculpture by Picasso erected in homage to Guillaume Apollinaire who died in 1918. This was commissioned in 1958 by the local authorities, and the sculptor chose to execute an over-lifesize portrait of Dora Mair, a painter friend. It was, appropriately enough, set up in this garden so well known to Apollinaire and opposite the *café des Deux Magots* where he used to meet his writer and painter friends. Such people still meet here today, except that, during the summer—a time when most Parisians are out of Paris—it overflows with tourists. Between the wars, again apart from the summer months, this café was quiet and sedate, at least in the interior where writers and poets congregated to engage in long discussions or to write or read in peace. Their numbers were then augmented by serious intellectuals and painters from all over the world. The *Sixième* was not the spectacular artists' quarter it became in the '50's when it was the haunt of Existentialists, and the *Deux Magots* is not, and never has been, a cheap café frequented by needy students. Its position at the wide carrefour with a superb view of the old church and the busy life of the Boulevard St Germain insures its continued popularity, no matter in which direction the tourists may migrate in the future.

Almost next door, the *Flore* is nearly as crowded, and is well-known as the meeting place of rather odd types, as well as of a cross-section of international intellectuals.

On the opposite side of the boulevard, at the corner of the rue de Rennes, where the glittering *Drugstore* now stands, the *Brasserie St Germain* used to act as a good foil to the *Deux Magots*. It was modern, neonlighted, with plenty of chromium plate, and was mainly for transient customers, though it had its special *clientèle* and served superb oysters. It is very much missed in the quarter, though doubtless the discothèque atmosphere of the *Drugstore* attracts a crowd of young people and tourists, especially since, in Paris, it is entirely up-to-date to favour American or typically English establishments. Even the 'British pubs', which have been opened recently, are a great draw and you will find the *Bedford Arms* near the Marché St Germain, behind the *Drugstore*, very authentic-looking. It boasts engraved glass windows, Turkish carpets, cold joints under glass covers and Guinness and 'Red Barrel' on sale and, best of all, a barman looking rather like a nineteenth-century cricketer, but you will have to pay considerably more for your half-pints than you would in England.

Close to the *Drugstore*, the *Brasserie Lipp* is another café with a very special character, which serves superb dishes and excellent beer. It is by no means cheap and is frequented by established writers, journalists and painters with whom it is very popular for 'snack' lunches and late suppers.

As a workaday centre, I have always favoured the more humble *Café Bonaparte* set back from the *Deux Magots* and the church. It has no very marked character but it is long-established, cheerful, cheaper than the others near-by, and you can work quietly over a beer or a coffee for most of the day. Admittedly the pavement is very narrow here, so there are only a few tables outside.

Most visitors staying for any length of time in Paris want to explore this area at leisure and discover their own bars and restaurants as well as whatever aspect of the great variety of nightlife they wish to patronise. There are restaurants of every

category, some deceptively simple-looking but really expensive, and there are others, which, despite the popularity of the quarter, remain remarkably cheap.

Since even *prix-fixe* meals have become rather expensive everywhere for those with limited cash, it is often cheaper and better to eat *à la carte* at one of the crowded, friendly places where harassed waiters are perfectly willing to serve a single copious dish and beer or wine. You will almost certainly sit six at a table built for four, but you will make friends, eat well and even have itinerant musicians serenading you with banjo or violin. Look for the short menu, handwritten and pasted in the window, and note that the cheapest places serve mainly offal, but appetisingly served.

Along the boulevard, away from the small streets, you can feed more cheaply still, either at authentic students' restaurants which are often entertaining, but where you will have to give proof of being a *bona fide* student, or at the many self-service and snack bars, at some of which you can have a dish at the counter. I must admit I have never found these amusing or as good value as their counterparts in London and I would always sooner buy carefully at one of the exciting delicatessens at rather less cost, or stock up in any of the many markets in the quarter. In the evening, in the side streets, there are a number of places serving hot dishes to take away, such as pizzas or even casseroles, pies and roast with vegetables. The most expensive way to economise is to do as in Britain and have large coffees, pots of tea, soft drinks, buns and sandwiches which can easily cost more than a full meal. Remember, above all, that you will pay very much less for your coffee or drink if you take it in a humble place and stand up at the bar to drink it. The cost of upkeep and the taxes on terraces are heavy, so waiter service at a table will obviously make your drink more expensive, but to most people the comfort and pleasure of sitting at a terrace is worth the extra cost.

Between the wars, you could get rooms in some of the then rather ramshackle hotels in this area for around a pound a week, including more-or-less running, more-or-less hot, water. It is still possible to find reasonable accommodation, unless you must have luxury, though further from the centre this will be cheaper—but there will be less choice and probably less available fun.

The group of small streets turning off the boulevard St Germain on either side of the rue de Rennes, are of a special interest; to the west, the rue du Dragon has been the home of a number of artists as well as at one time containing the workshop of Palissy, and has always had an artistic tradition. The Académie Julian at number 31 is of paramount interest to the painter, for it was founded in 1860 by Rudolph Julian to serve as a kind of preparatory school for the Ecole des Beaux Arts; it was originally situated in the Faubourg Montmartre and then in Montparnasse. It finally became established in the rue du Dragon where it attained its great popularity in the late 1880's. At that time Bonnard and Vuillard used to meet there and, later, Matisse studied under the rather mediocre, but competent, painter Bouguereau; in the early years of the twentieth-century, Derain and Léger were numbered among those who were to become famous. It is still possible for a foreigner to attend a course of lessons if there is room; or to arrange to draw from a model, unaided, for a modest fee, by simply applying for particulars at the office. Incidentally, there is a second Académie Julian on the Right Bank, but it is in a dull quarter compared with the one on the Left Bank. (In the last chapter of this book you will find a list of other places where you may study art or draw from models.)

The houses on the rue du Dragon are remarkable for some lovely wrought and cast iron; more especially a corner balcony with the 'dragon' incorporated into it. There used to be an early eighteenth-century mansion, with an entrance in the rue de

Rennes, the Cour du Dragon, believed to be at one time a coaching inn. The superb doorway, again embellished with a dragon and wrought-iron balcony, has been removed (but preserved) to make way for a cinema.

On the other side of the rue du Rennes and the rue Bonaparte, the rue des Canettes, the rue des Ciseaux, the rue Guisarde and the tiny little rue Princesse, where the eighteenth-century painter Chardin worked, have all preserved their ancient aspect and escaped the onslaught of building enterprises. Here too are a number of attractive bars and restaurants, none of them really expensive, but costing more than you might think, since some of them have become rather pretentious.

Parallel with the rue des Canettes in the rue Mabillon, the *Charpentier* is a good, simple restaurant and bar, serving excellent full meals and cheap dishes and, at the same time, acting as a meeting place for the Guild of Journeyman Carpenters. The Marché St Germain, flanked by this street, displays everything from food to flowers to knitting wool and is always open and particularly lively and colourful on Sunday mornings.

It is quite impossible to describe all the fascinating streets in St-Germain-des-Prés. It is an area of gracious houses with superb entrances and wrought-iron balconies. The streets are narrow, with interesting sky-lines of chimneys and mansard roofs, decorative urns, set on tall pillars, spacious courts and a labyrinth of small courtyards and gardens, many of them roofed-over or used as store places for the antique shops which abound in this quarter. There are so many of them, and the shop fronts are so beautifully arranged, that they are lighted late in the evening at least once a week. Some have the aspect of luxurious French elegance, some the modified charm of an English drawing-room, others are sharply modern or entertainingly Surrealist, or even display a rather odd assembly of Victoriana. Wander through some of the passageways in the

daytime and ask to look around the strange conglomeration of rocking-horses, marble busts, lamps and odd articles of every description to be found in the courtyards at the back of the rue Bonaparte or the rue de l'Abbaye, though it may take you some time to discover the entrances.

Of all the streets in this region, I find those running down to the quays from the north and east of the church the most fascinating. Most of them have literary, historic or artistic associations and are also picturesque, with attractive shops and galleries. The rue Bonaparte, the rue de Seine and the rue Mazarine converge on the quayside and are linked by a number of attractive streets and squares. If you turn down the rue Jacob and then right again, the rue Furstemberg will lead you into the Place Furstemberg, one of the smallest squares in the world—almost provincial in aspect and completely secluded from the bustle of Paris. It was built in 1699 by Cardinal Furstemberg, on a site of the abbey stables; numbers 6 and 8 are part of the old building. Delacroix lived and worked at number 6, and he built an adjoining studio which Bazille and Monet shared; from their window they could watch the old man at work. He, like them, had been an innovator and a leading figure in the Romantic Movement but he died, almost forgotten, in this delightful corner of Paris in 1863.

Until 1968 this square was known in drawings and photographs by its four trees round a single lamp post; now alas, one has been blown down and those remaining give a slightly unbalanced impression; even so, this in no way detracts from the delightful appearance through the branches of the yellow-washed façade of Delacroix's studio. For some reason, the new silhouette has a slightly oriental effect, as though the branches were washed in with Chinese ink. There is a small museum where the painter worked and an annual exhibition of some of his paintings or drawings is held there. In the rue Fursterm-berg there is a school of Ecclesiastical Art which specialises in

the techniques of frescoes, stained glass, tapestry, metal work and sculpture.

The rue Visconti, a small street which runs from the rue Bonaparte to the rue de Seine, has many interesting connections: Ingres ran a school of painting for nearly ten years and it was here too, that Delacroix lived for a time at number 17, where Balzac had installed his famous printing works which his colossal debts forced him to close down in 1828.

Parallel to it, the rue des Beaux Arts, needless to say, leads to the Ecole des Beaux Arts in the rue Bonaparte, and on the corner of the two streets there is a good cheap restaurant with an art student *clientèle*, where you can get attractively served meals in a sympathetic cheerful atmosphere. There is also a first-class art shop and many others, which are equally good, nearby. At the other end of the rue des Beaux Arts in the rue de Seine, you will find *Augustin*, a really amusing restaurant with long tables filled to overflowing from midday until late into the evening, where everyone talks and enjoys good food. But then the whole of the rue de Seine is full of entertainment with small bistros, cafés, art shops, book shops and exciting small galleries, where there is always something modern, something traditional and often something frankly outrageous to look at.

Rosa Bonheur worked in the rue de Seine in the nineteenth century, and had the most extraordinary studio as we can see from an old print. Through an archway from her working room was a stable with a live pony in the straw, sheep in pens, cats and rabbits and dogs running loose and tubs full of shrubs and odd plants. There were even farm carts, harness, stuffed birds and the stuffed heads of cattle among an astonishing assortment of props. Rosa was very much of a character and she used to do a lot of sketching in the Abbatoirs, and even had a dispensation to wear trousers, as only men were allowed to work there. She was held in great respect for what were con-

c

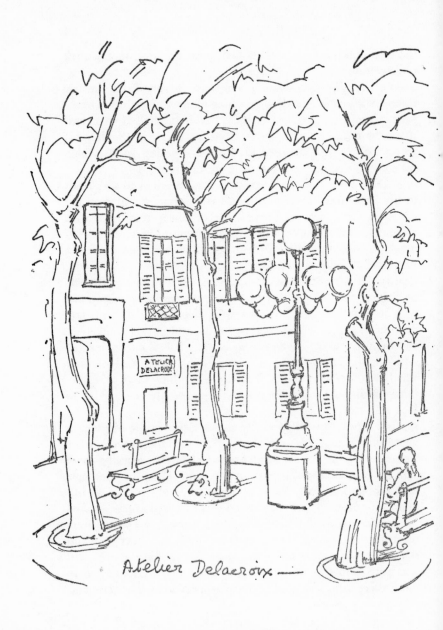

Atelier Delacroix

sidered, in some circles, to be brilliant works of art and, though public taste has since changed, she certainly knew a great deal about animals and painted them accurately and sympathetically. At the river end of the street, a triangle of land forms a little shady garden with creepers clambering up the blind facing of the buildings which suddenly stop short.

The riverside is reached through an archway in the Palais de l'Institut de France, one of the finest pieces of architecture in Paris and best seen from the river or even further away on the opposite bank. It was designed towards the end of the seventeenth century by the architect le Vau, and the building centres round the graceful, gilded dome—the Coupole—under which the Académie Française meets once a year. Next to it, the Hôtel de la Monnaie is a classical building of the eighteenth century and rather tame in comparison; it is still a mint and you can watch the coins being struck, but more interesting still is the valuable collection of coins and medals displayed in the beautiful rooms.

The Pont des Arts opposite is for pedestrians only, and from it there is a superb view both ways up the river, to the Ile de la Cité and the Ile St Louis as well as to the Louvre and the Eiffel Tower. The quayside bookstalls present a lively scene and more and more of them open up and display coloured prints and paintings as the day continues.

To the east you will find streets with such inviting names as Gît-le-Coeur, Hautefeuille and, beyond the Boulevard St Michel, Le Chat-qui-pêche, but before going deep into the Latin Quarter, there is still much to be seen near the rue de Seine. Two streets link it to the rue Mazarine—the rue Jacques-Callot, named after the seventeenth-century artist, and the rue de Buci which leads into the square and market of the same name, where pedestrians and shoppers take over in the early morning and in the evening, crowding along the streets to buy the best of the mounds of fruits, vegetables and meat enticingly

displayed on the stalls. There is indeed no end to the discoveries to be made in the maze of streets, in this area of the Left Bank.

The rue Mazarine is also of the greatest interest. For the first few yards, it is called the rue de l'Ancienne-Comédie where the *Café Procope*, the first coffee house to be opened in Paris, still stands, and was a famous meeting place for intellectuals for centuries. It is now a medium-priced restaurant of great charm, keeping its delightful seventeenth-century façade and decorated interior. Close by, is a large entrance leading into the Cour de Rohan where there are fragments of a tower and

the twelfth-century Town Hall, but its main attraction is the ancient houses and the old well-head, and a graceful tree silhouetted against the rather mouldering façade of the tall house. Not long ago, there used to be a tiny second-hand bookshop in this courtyard, and the owner also had a collection of old toys. Although, as far as I know, this has no direct association with painters, it certainly has with writers, including Anatole France who went to school here; it has a great

attraction for anyone interested in the less-known corners of Paris.

Leading out of the Cour de Rohan is the Cour du Commerce, a little less remote-looking and not quite so attractive, although there are a few countrified shops and restaurants along a rather uneven cobbled walk.

Before dealing with the streets, monuments and museums immediately to the east of the Boulevard St Michel, I shall describe the area further east since it is mainly the street scene which is of interest here. The rue Monge is rather dreary, but it has some good restaurants and it will lead you to the Arenas of Lutetia, if you enjoy looking at these rather boring Roman remains which must be of interest to the specialist, but do not really present much of a spectacle. The rue Mouffetard runs almost parallel to the rue Monge and is much more interesting, especially on Saturdays and Sundays when the street market is in full session and you can wander down the steep hill past shops which still retain some of their medieval flavour, more especially in the old iron shop signs indicative of the various trades and in their open shopfronts. You may well see a flock of goats driven along by gipsies, and you will certainly see the herb man with his skilfully loaded donkey, which carries a diminutive shop counter on his back. At the western end of the rue Mouffetard, the Place Contrescarpe, though still rather sordid, is beginning to attract painters and writers. It has always had the aspect of a provincial square, with its trees in the centre, its either brash or rather shabby cafés and shops, and the teeming market street leading out of it. A few years ago it was the haunt of *clochards* who slept over the warm gratings at night, but now the lights in the cafés are full on and there is a certain amount of night life.

The nearby Jardin des Plantes is of interest to painters, largely because it is very likely that some of the artists living in Paris drew inspiration from it for settings for their more

exotic paintings, but also because it has a strange, slightly forlorn attraction. Since it is officially the Natural History Museum, it boasts a menagerie and natural history galleries, a fine botanical garden and a great number of exotic plants; its selection of wild and herbaceous plants is unrivalled. Although there is a more ambitious garden like this in the Bois du Boulogne, this is, in some ways, more interesting, for the nucleus of the menagerie was formed from the royal collection at Versailles and the garden is beautifully situated near the riverside. In early summer, the great sweeps of peonies are a splendid sight.

The garden is just within the *Cinquième Arrondissement*, adjacent to the Gare d'Austerlitz.

V

MONUMENTS OF THE LEFT BANK

Monuments of the Latin Quarter – St Julien-le-
Pauvre – The Cluny – The Panthéon – St Etienne-du-
Mont – The Val de Grâce – The Gobelins

Since it contains several important churches and monu-
ments as well as a major museum, I am devoting a separ-
ate chapter to the broad strip of the *Cinquième Arron-
dissement* immediately to the east of the Boulevard St Michel
and along the entire length.

Beginning from the quays opposite the Ile de la Cité, and
just behind the Square René Viviani, the church of St Julien-
le-Pauvre is a very ancient building which, in the nineteenth
century, was handed over to the Malachites, a sect of the
Greek Orthodox Church. Originally built in the sixth century
on the crossing of the great Roman road to Orléans and the
south, this church, where Grégoire de Tours stayed when he

used to come to Paris, was destroyed by the Normans in the ninth century and re-built by the Benedictines in the twelfth and thirteenth centuries as a hostelry for pilgrims. In the Middle Ages it served as a parish church for University students and professors but, under the Revolution, it became a storehouse. The remains of the building now stand in a little courtyard formed by the bays of the church and some old houses which now have cabarets in their cellars. The church retains its Gothic ceiling over the side aisles although the vaulting of the nave is seventeenth-century work.

The view along the rue St-Julien-le-Pauvre, with its assortment of roofs and chimneys, to Notre-Dame, is outstandingly attractive. Closeby, the beautiful Gothic church of St Séverin was erected on the spot where the hermit Séverin lived. An oratory was first built here in his honour, but was later replaced by a church, and during the Middle Ages this served as a church for the whole of the Left Bank. The present building which kept the Romanesque façade of the earlier church, was begun in the thirteenth century and, as the work proceeded, the final details were completed in the flamboyant style. The main west portal was brought from a *Cité* church in the mid-nineteenth century. The interior is most impressive, with its wide double ambulatry, its ribbed vaulting and some late fourteenth-century glass from St-Germain-des-Prés, including a tree of Jesse, in the west rose window, designed in the early sixteenth century. The murals were painted in the nineteenth century.

A little garden of chestnut trees now covers the former cemeteries, and the fifteenth-century ossuaries can still be visited. In the numerous small streets in this area and a little further east and west a number of exotic restaurants offer the food of almost any country in the world at reasonable prices. The sophisticated *Cris de Paris* opposite St Julien-le-Pauvre does not however fall into this category, for it is expensive,

but the delightful décor of old Paris, the good food and service, are value for money.

A very short distance to the south, at the corner of the Boulevard St Germain and St Michel, the Hôtel de Cluny is (apart from the Hôtel de Sens) the only fifteenth-century private residence in Paris to have kept its original form of the flamboyant Gothic style which was current immediately before the Renaissance. It was built close to the site of the spa of Lutetia which was constructed at some time during the second or third century. Later, houses were erected on part of the ruined site but the precise date of the present mansion is not known, though it was completed early in the sixteenth century. Many members of royal families stayed here in the succeeding centuries and during the Revolution it became State property. It was abandoned in the early nineteenth century and occupied first by a printer, then by a laundry and was even bought by a surgeon who used the chapel for a dissecting room. The Roman ruins were bought by the city of Paris and in 1833 the collector and art expert, Alexandre Alec du Sommerard, came to live in the Hôtel and displayed his rare treasures in the rooms. He died nine years later and the State bought from the civic authorities the house and its contents as well as the Roman remains, but it was stipulated that these latter should be turned into a museum. Two years later this project was realised. Everything in this collection is of superb quality and a great many of the types of art displayed cannot be seen elsewhere; the examples of early tapestries, such as the *Dame à la Licorne* series, are unique.

After complete re-organisation and re-arrangement, the Hôtel de Cluny is now entirely dedicated to works of art of the Middle Ages and the Gallo-Roman collection. The former Renaissance and classical objects now in store will eventually be shown elsewhere. The rooms are arranged according to

subject matter rather than chronologically, so it is best to visit them numerically.

The first room is mainly devoted to costumes, but of supreme interest is the wonderful tapestry of the *Offrande du Coeur* which was probably designed in Arras in the first years of the sixteenth century and woven by travelling weavers who could set up their looms anywhere. The deep blue foreground is dappled with flowers, treated decoratively, and delicate trees of different types in light colours stand out against the same deep blue. Beautiful little animals, hares and rabbits and birds, dart about amongst the foliage. Against this wonderful backcloth, the knight, in a scarlet cloak, offers his heart to a serene noble lady seated on a hillock, with a falcon on her wrist. Rooms 2, 3 and 4 are all given up to tapestry and embroidery and the museum is fortunate in having three small tapestries lent by the museum of Angers, belonging to the famous Apocalypse cycle, woven towards the end of the fourteenth century. In room 2 there is a fifth-century altarpiece from north Germany. In room 3 there are two large embroidered panels of superb workmanship: one illustrating the life and miracles of St Martin in a series of medallions, the other, a fourteenth-century altar cloth, showing the life of St Mark and St John. Here too are early fourteenth-century statues and five of the six tapestries of *La Vie Seigneuriale* which were woven in the early years of the sixteenth century, with blossoming trees, flowers, birds and beasts, and even butterflies, strewn over the *Mille Fleurs* background, beloved of the Middle Ages. *The Departure for the Hunt, The Bath, The Walk, The Concert, The Reading*, all depict the 'lordly life' of the time; and we are shown, in *The Bath*, for instance, such delightful details as water flowing from the carved bath through a lion's mouth to make a little pond for ducks to swim on. The whole of this fourth room has been arranged in such a way as to give the atmosphere of an aristocratic house in the reign of Louis XII

(1499–1515). In this it succeeds admirably, with the fireplace of early fifteenth-century date, brought from a house in le Mans, the contemporary furniture and the tapestry-hung walls.

The next two rooms are given up to the work of carpenters and cabinet-makers and include church pews and stalls and all the woodwork details of fine town mansions including some sculptured coffers and panels. A misericord from Beauvais, designed at the end of the fifteenth century, depicts a lifelike carpenter at work. The vast room which was in use in Roman times, contains a large number of paintings and carvings, with some particularly lovely fourteenth-century statues of the Virgin and Child, but perhaps finer still is the marble *The Presentation in the Temple* which is believed to be by André Beauneveu.

Of the paintings, the most impressive is the fifteenth-century Pietà panel from the Hospice of Tarascon. It is extraordinarily dramatic and designed with great simplicity and economy. There are delightful details in the treatment of drapery and hair and in the brilliant gold of the haloes and the decorative background. The following room also contains paintings and sculpture but of rather earlier date, including four of the apostles carved in the thirteenth century, for the Sainte-Chapelle, but now in a damaged state. Decorated columns from the Basilica of St Denis and a very lovely fourteenth-century ivory statue of the Virgin, but most moving of all, a painted wooden statue of St Louis which may be an authentic portrait of the king. Room 10 displays works as early as the seventh century, but the general impression is of the eleventh century, created by the columns and capitals from St-Germain-des-Prés.

The most beautiful tapestries in the Cluny, are those of *La Dame à la Licorne*, displayed in room 11 and probably depicting scenes in the life and wooing of a young woman living in the valley of the Loire, towards the end of the fifteenth century.

They are displayed alone in a circular room especially designed
for the purpose. The Lady of the Unicorn stands within a
magic circle in a rose-red background strewn with flowers and
birds and in successive panels she gracefully stands or roams
amongst the plants, the trees and the wild life of the woods.
Five of these panels illustrate the senses: sight, smell, hearing,
touch and taste, and the slender girl mimes these senses by
choosing a flower with the sweetest scent—a sweetmeat—for its
delicious flavour—and resting her hand on the unicorn's horn
to bring good fortune; a delightful touch is added by her show-
ing the unicorn his reflection in a mirror. These five panels
culminate in what is perhaps the most lovely of all—*A mon
seul Désir*, where *La Dame* chooses a jewel from a little box,
symbolising the thought that she herself is the jewel chosen
from all the beautiful women of France by her lover who
commissioned the hangings for her.

Even though this room is in the middle of the itinerary sug-
gested, I always like to come here last, or to make a special
visit for this room alone, since these tapestries are among the
greatest treasures of Paris. The next room is devoted to enamel
work and displays a magnificent Limoges *Christ in Majesty*
and examples of shrines and box bindings, some as early as the
twelfth century.

The jewellery room displays Gallic and Barbaric pieces,
seventh-century Visigoth crowns, and lions' heads of rock
crystal. Room 14 has a fine collection of metalwork including
silver cups and a sixteenth-century drinking horn standing on
birds' feet. The remaining rooms are given over to stained glass,
mainly of the thirteenth century, to ceramics of which there
is a superb collection of Italian work, and to all kinds of small
medieval *objets d'art*. Two fifteenth-century Books of Hours
need special study and the ecclesiastical treasures of art in
room 19 are among the most precious possessions of the
museum, more especially the Basle altar-piece, a splendid

eleventh-century frontal of gold and precious stones and pearls, given by the Emperor Henry II to Basle Cathedral. Golden figures in high relief stand beneath Romanesque arches supported by columns with decorative capitals.

The chapel is one of the most elegant remaining examples of church architecture of the end of the Middle Ages; the star vaulting spreads out gracefully from a single slender pillar and the sculpture in the window vault depicting angels with the instruments of the Passion. The walls are hung with yet another series of fifteenth-century tapestries, this time illustrating the life of St Stephen.

Rooms with examples of metalwork, iron and pewter, including a fourteenth-century lead font, lead to the last room and portraits of the Du Sommerard family.

Close to the Cluny, in the rue de la Sorbonne, you will find the main buildings of the University of Paris. They have been rebuilt many times and, though not unattractive, are of no great artistic value. By continuing down the road, you will soon come to the rue Soufflot and arrive at the Panthéon, which has, like the Pantheon in Rome, a Corinthian façade surmounted by a dome lightly balanced on a colonnaded lantern, features which combine to give a gracious outline to the building. Originally built as a church by Soufflot in the eighteenth century, it was turned into a Temple of Fame during the Revolution and still contains the tombs of great men such as Victor Hugo and Emile Zola. For artists, the chief attractions are the murals by Puvis de Chavannes, illustrating legends of the life of Ste Geneviève, the patron saint of Paris, whose name is given to the slope on which the Panthéon stands—the Montagne Ste Geneviève. Other painters were also employed, but their work was markedly inferior. Although Chavannes' paintings now appear rather cold and lifeless, they are masterly in design and simple in their dramatic force. The painter tackled the problem of painting on a large flat wall

space and recognised that simple treatment was essential for the best effect. While he was carrying out the work, he still lived in his studio in the Place Pigalle and would walk over to his second large studio in Neuilly where he worked from 9 in the morning until 6 at night.

Nothing could present greater architectural contrast to the Panthéon than the church of Ste Etienne-du-Mont a few yards away. The whole design of the church is entirely lacking in unity and appears to be a number of churches of different character superimposed upon each other, pillared, pedimented and gabled with a final tower to one side, crowned with a cupola. It certainly gives the effect of clambering awkwardly towards the sky and exemplifies almost every period of architecture in individual details.

The much-prized rood-loft, with its central portion of sixteenth-century Renaissance design, has two flanking spiral stairways leading to the choir gallery. Although there is a certain monumental grace in the sweep of the stairways and arching of the gallery, I find it only impressive in its overwhelming elaboration and size.

If you walk down the rue St Jacques you will see the handsome buildings of the Val de Grâce, once the house of Benedictine nuns, but used as a military hospital since the late eighteenth century. The church was built by François Mansart, but the graceful dome with its characteristic silhouette was added by Viollet le Duc who was inspired by the design of St Peter's in Rome.

For anyone interested in the weaving of tapestries and the history of the craft, it is not far from the Val de Grâce to the Gobelins museum or display rooms and the manufactory. From very early times, tapestry workshops existed in France and they were particularly flourishing towards the end of the thirteenth century, but by the fifteenth century the best work was being produced along the banks of the Loire. When the French court

left Paris, craftsmen and artists established themselves near the river and worked for the owners of the large *Châteaux* in the neighbourhood.

The district where the Gobelins factories now stand is still attractive, but it was once practically open country and the little river Bièvre which came into the city by the Poterne des Peupliers flowed into the Seine by the Austerlitz bridge. The water was particularly good for dyes and was used by members of the Gobelins family at some time during the fifteenth century when they established themselves on the banks of the river so that they could experiment with a very brilliant scarlet dye. Although the Gobelins family seems to have died out in the seventeenth century, the name was kept and others succeeded them at the works. During the reign of Louis XIV the statesman Colbert administered the whole district as a kind of garden city for craftsmen, taking pupils and apprentices and allotting to the artisans patches of garden which must have been most attractive. Even now the redesigned square, René le Gall, succeeds in maintaining the atmosphere of that time. The manufactory suffered many set-backs and periods of unproductiveness, but came into its own again in the eighteenth century. Unfortunately the designers had lost the early feeling of bold simplicity for this technique and were inclined to reproduce what were really paintings in wool. The huge range of colour they needed for this, and inferior dyes, contributed to fading, with the result that most eighteenth- and nineteenth-century tapestries have a dull, brownish-green effect and lack the brilliant glowing colours of the early hangings, such as those in the Cluny museum. Tapestries and carpets are still woven in the workshop and some of the chief traditional work can be seen on display in the three rooms reserved for the purpose. It is also possible to watch the weavers at work on some afternoons in the week.

During the Second World War, the painter Jean Lurçat

became very much interested in weaving and brought about a renaissance in the art of tapestry. With a group of friends he studied the simple methods and smaller range of colours used by the early craftsmen, and they worked and are still working with great success to recapture the brilliance and fine qualities of early tapestry.

VI

THE ILE DE LA CITÉ AND THE EASTERN SECTOR

ILE DE LA CITÉ – NOTRE DAME – ILE ST LOUIS – THE
MARAIS – THE CANALS – LA VILLETTE – BUTTES-CHAUMONT –
BELLEVILLE

THE Ile de la Cité, geographically in the centre of Paris
is, of course, the oldest part of the capital, for it was here,
on what was then a marshy little island, that the Parisii
settled in their flight from wild tribes. When the Romans came,
they found the island too small for their needs and built temples
on Montmartre and on the Left Bank on the eminence later to
be called the Montagne Ste Geneviève. By the fourth century
there was a palace on the island itself, where the emperor
Julian lived, and by the sixth century Clovis, King of the
Franks, had conquered Gaul and made Paris his capital. Late
in the ninth century the Normans in their conquests tried to
force their way through Paris, but they were repelled by the
endurance and bravery of the citizens. Even so, by the year
1000, the great famine which spread through Europe had
reduced vast areas to poverty and distress and for more than a
century anarchy and economic troubles prevailed.

With the passing of the millennium people took heart and began to build churches and abbeys, and by the twelfth century a good measure of prosperity had returned. It was then, in 1163, that the Bishop of Paris, Maurice de Sully, set about transforming the small Romanesque church of Notre-Dame into the splendid Gothic cathedral it is today. The site had been a religious centre for centuries—at first a Temple, then a Christian basilica. It is not known who the chosen architect was but although the building took over 180 years to complete, his plans were followed so closely that there is perfect unity throughout, relieved by the imagination of the masons who left their individual stamp on the carved pillars, the portals and the gargoyles on the roof. Obviously Notre-Dame is too well-known to be described here, and the interested student will want to explore it for himself with the aid of a very detailed guide book; but even the non-specialist cannot help being impressed by the grandeur of conception of the whole building, by the stained glass within and by the superb carvings within and without. The cathedral stands in a splendid setting at the eastern end of the island but some of the effect of height has been lost since the steps leading to the portal disappeared when the level of the square was raised. The approach from the front is, nevertheless, impressive with the fine proportions of the sturdy towers, the long line of restored statues of the Kings of France and the three carved doorways. St Anne's Portal on the right has in its tympanum the oldest sculpture in the Cathedral dating from 1170 and depicting the Virgin enthroned; the Romanesque statue forming the central pier is a copy of the original in the Cluny museum.

The famous Last Judgement tympanum on the central portal, in common with nearly all the carving, including the figure of Christ on the pier, was heavily restored in the nineteenth century by Viollet le Duc; but the most beautiful work is to be found on the left, in the Virgin's Portal. The tympanum

is designed simply and dramatically to tell the story of the life of the Virgin : prophets announce her coming and her death and resurrection are enacted in one panel, culminating in the Coronation at the apex. In the surrounding arches and flanking piers are infinitely lovely and imaginative carvings of fruit, flowers, foliage, the signs of the Zodiac and, conceived even more imaginatively than these, the activities of the months of the year.

All three doorways have particularly fine wrought ironwork, or rather, hinges carried forward in decoration to cover the whole surface of the door. Originally the statues were brilliantly coloured against a background of gold, and there still remain a few traces of colour which have been revealed by recent cleaning and restoration. You will find many details to delight you in the interior, but of primary importance are the stained glass, the carvings and the fourteenth-century *Virgin and Child* which has the usual elegance of these Gothic Madonnas, although she holds the child somewhat stiffly. The statue was brought from another church, for there were indeed several other churches on the island and a network of narrow streets and alleys until new Law Courts were built by Napoleon III, when many of the old buildings were cleared away. The rue Ursins and the rue des Chanoinesses are the only old streets to remain, and these contain one or two really old houses.

For complete contrast of effect, walk across to the western end of the island, to the Sainte-Chapelle, half-hidden in a courtyard of the Palais de Justice. For choice, go by the Quai des Fleurs and the Quai de Corse, ending up at the Place Louis-Lepine where you will find the most glorious display of flowers in this, the most colourful of all the Paris markets, and a fitting preamble to one of the most perfect small Gothic buildings in France.

Saint Louis did not find the little church of St Nicholas,

attached to his palace, beautiful enough to hold the relics of
the True Cross and so he had this delicate lace-like structure,
with spires and pinnacles soaring into the sky, built as a kind of
outer, jewelled casket to contain the treasures already safely
enclosed in a reliquary of exquisite craftsmanship. This chapel,
of infinite lightness and grace, took less than three years to
build, with its lower church for the servants and retainers,
and its upper church for the King and the nobles, connected
by a little passage to the private apartment of the palace, so
that the saintly King could come and pray whenever he wished.
The reliquary was melted down during the revolution and
all that was saved is now in Notre Dame.

The portal is formed of two porches, one above the other,
decorated with statues and interesting motifs, but these are
nineteenth-century restorations and not of very good workman-
ship.

The interior of the ground-floor church is low, with painted
decoration and handsome carved oak bosses, but the Upper
Chapel, reached by a spiral staircase, is a miracle of light and
colour. The whole of the lofty interior has been repainted and
gilded but it is really the brilliant sparkling colour of jewels
from the stained glass of the slender windows which gives the
chapel its rare loveliness. Restorations to the glass have been
done with such genius that they are barely distinguishable.
Detailed description can only detract from the unique visual
experience of seeing this interior.

As for the rest of the Ile de la Cité, it has the charm of all
islands, however urban, perhaps best exemplified in the delight-
ful Place Dauphine, a shady little square, built in the seven-
teenth century. In my experience, it is always sunlit and
dappled with shadows, and only the sound of fluttering wings
and cooing doves to break the quietness; save at lunchtime,
when the restaurant *Chez Paul* is patronised by judges and
barristers, and at night, when it is filled with writers and

painters immersed in long discussions. There are indeed a few studios here : one on a top floor, has a huge plate glass window, forming the outer wall, which gives a view of the whole of the Seine, enchanting at all times, but miraculous at sunset.

At the entrance to the *Place*, stand two very beautiful seventeenth-century houses of rose and coloured brick; the Pont Neuf, which passes in front of them, was the first bridge to be constructed in Paris without houses on it. Since it was built by Henry IV so that he could have a clear view of Notre-Dame from the Louvre, a very fine equestrian statue of him was erected in 1818 in the square on the island between the two sections of the bridge. This imposing statue of the king in all his nobility is the work of Lemot.

The tranquil, green gardens of the Square du Vert Galant fill the triangular corner of the island beneath the Pont Neuf.

For a superb view of the Ile de la Cité, the Ile St Louis, the winding river and, for that matter, almost the whole of Paris, climb up to the tower of Notre-Dame.

The Ile St Louis is linked to the Ile de la Cité by a footbridge. Until the seventeenth century, this second island was merely a group of sandy islets with a few fisherman's huts, but when the population of Paris began to grow, a contractor called Marie obtained permission to join them together and build a whole series of mansions. These were to be mainly for the new rich, for government officials and contractors; but the island gradually became a quiet retreat for the nobility and a centre for artists, which indeed it still is today.

Even though it is right in the centre of Paris, the Ile St Louis preserves the atmosphere of a charming provincial town, with its quiet central shopping street, a single church and aristocratic houses along the shady quays. Only one of the original bridges connecting the island with the north and south banks remains— the graceful Pont Marie named, presumably after the con-

tractor. A favourite subject for painters, its arches form a lovely composition with the old houses, the trees and the river.

The best way to see the island is simply to stroll right round the quays and then turn in to look at the Jesuit church—of no outstanding architectural distinction, it is true, but remarkable for its splendid collection of fourteenth- and fifteenth-century vestments from the Abbey of Longchamp, which the sacristan will show you on request.

If you have crossed by the footbridge first, turn left and follow the Quai de Bourbon to the right, since this is the more attractive side of the island, where all the mansions remain in their original state. At number 15 Quai de Bourbon, the Hôtel de Charron is a very fine mansion of pale golden stone, with mansard windows breaking the line of the red tiled roof. The large courtyard has the remains of a turreted tower and an ancient well. The rich façade of the Hôtel de Jassaud hides a large garden courtyard.

If you continue past the Pont Marie, you will come to the Quai d'Anjou, where you will find the Hôtel de Lauzun, distinguished by delicately moulded and gilded drain-pipes, but very restrained compared with the interior—elaborately decorated with gilt sculpture and paintings, mainly the work of Lebrun and Le Sueur. The house was bought in 1928 by the City of Paris, to serve as reception rooms for great Civic occasions and it was here that Princess Elizabeth and the Duke of Edinburgh were received on their State visit. A few houses to the east, the Hôtel Lambert or Le Vau, stands on the end of the island; it was built by Le Vau for President Lambert and was also decorated by Lebrun and Le Sueur. Daumier lived nearby and a number of other nineteenth-century artists. Delacroix was a constant visitor to friends on the island, and in the present day, Marc Chagall has a studio here, although he does not often use it. A few years ago, a whole colony of Russian

painters lived on the Island and used to spend Friday evenings together at the *Deux Magots* in St-Germain-des-Prés.

At the very tip of the island, there is a little garden and, below the quayside, you can see the blocked up entrances to the houses from the river. On the Pont de la Tournelle, the tall slender statue of Ste Geneviève looks up the river to the east, the direction in which the saint went on her dangerous errand to find food for the starving people of Paris.

The Quai de Béthune and the Quai d'Orléans on the sunny, southern side of the island, are also lined with seventeenth-century mansions, with courts and gardens, but here there has been a certain amount of rebuilding. One first-floor flat is entered through a series of garden courtyards, with ivy-grown sculpture and well-heads and a sweeping staircase with a wrought-iron balustrade. Below the quays, a number of flat-bottomed boats are moored and, just after the Second World War, one inhabitant used to keep tame ducks here, which he fed every day; he may still do so, for all I know.

The inner streets of the island hide all kinds of curious courtyards behind the huge, rather forbidding doors, but these are not open to the public, and even the historic monuments are difficult to visit, except on special guided tours.

There are one or two restaurants dating back to the seventeenth century, but they are expensive. There is certainly a most wonderful view of Paris from the glassed-in terrace on the top floor of the *Tour d'argent*, in the Quai de la Tournelle just opposite the island on the Left Bank.

To the north of the island, on the Right Bank, lies the district of the Marais with an even greater variety of beautiful mansions in various stages of restoration and, in some cases, of decay. It is situated between the rue Vieille du Temple, the Boulevard Beaumarchais, which runs northwards from the Place de la Bastille, and the Seine. As its name suggests, the Marais was reclaimed from the marshes, but since open sewers

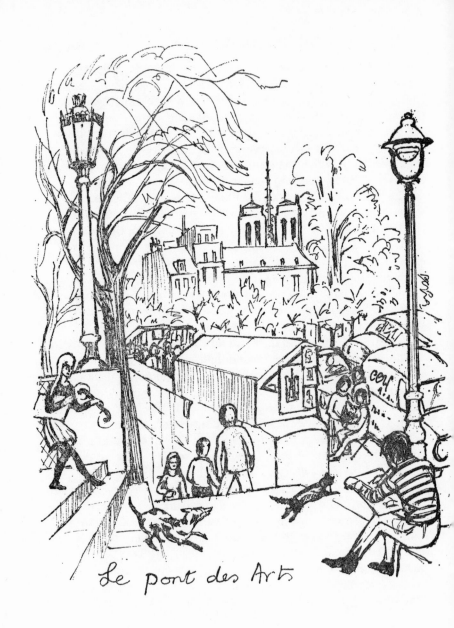

Le pont des Arts

crossed it in the Middle Ages, it became so unhealthy that the aristocracy gradually abandoned it to settle further west.

There are so many old mansions and enticing streets and alleys in this rather shabby area that it would be quite impossible to enumerate them all. About sixty have been classified as national monuments and the task of cleaning and restoring them is still going on, but rather slowly. Some have been restored to their former splendour and their courtyards are used for open air concerts in the summer, when they are floodlit. Only a few years ago the Hôtel de Sully was black with grime and its splendid portal led into a neglected garden. It is now a glory of golden stone, concealing a spacious courtyard and decorative garden façade.

The Marais is best explored in a very leisurely manner over several days, but even an hour or two's stroll through the maze of streets will reveal some astonishing architecture.

Among so large a number, I can only draw attention to a few, including of course the well-known Hôtel de Sens, in the rue du Figuier which is, with the Hôtel de Cluny, the only mansion remaining from the Middle Ages. For years it was neglected and dilapidated, and then it had a nostalgic medieval air, but since it has been restored so ferociously, it looks rather like a model, almost too good to be true, with its pepper-pot turrets, its sloping roof and deeply-arched doorways.

The streets which reveal the largest number of these buildings are the rue des Francs-Bourgeois, the rue des Archives and the rue Vielle du Temple. The Hôtel d'Albret, in the first of these, has an entrance portal surmounted by a richly-wrought balcony supported on lions' heads, and the pediment above the window has an *œil de bœuf* surrounded by decorative foliage. The Hôtel de Sandreville nearby also has some beautiful features worth looking for. The Hôtel d'Almeyras, at number 30, has a dignified, noble entrance portal, decorated

with masks and garlands and the Hôtel Hérouet, at number 42, a very pretty Renaissance turret with decorative carving.

Close by, in the rue Vieille du Temple, the imposing Hôtel des Ambassadeurs de Hollande has been superbly restored. The huge doors have sculptured panels of the head of Medusa alternating with *putti* holding garlands and, above, is a splendid relief of War and Peace. The façades onto the two connecting courtyards are equally decorative, with consols formed by children's torsos. The second of these was used for theatrical performances and the theatre is ornamented with statues and pillars and has a superb wrought-iron balcony. The Hôtel de Rohan is perhaps a little austere but has magnificent proportions and its gardens connect with the more charming Palais Soubise which is actually in the rue des Francs-Bourgeois. The courtyard façade, is a delight of perfect proportion. The columned entrance supports a second columned storey with a pediment decorated with graceful figures and statues, the whole combining to make this a fairy-tale palace. These two buildings, together with the towered Manoir de Clisson, form the Musée des Archives. On Sundays the archives are open to the public but the exhibits, being historical documents, are mainly for the specialist; nevertheless the visit is well worthwhile just to see the magnificent apartments with their mural paintings, mouldings and decorations; and it also gives an opportunity to have a more comprehensive look at the buildings and courts which cannot be seen from the road.

The museum of the History of Paris, displayed in the beautiful rooms of the Hôtel Carnavalet, is close by the rue des Francs-Bourgeois. Parts of this museum date from the sixteenth century and it was once the residence of Madame de Sévigné who was indeed a local inhabitant for, although she only lived for nine years in the Carnavalet, she resided in a number of other mansions in this quarter where she had many friends. Built around four courtyards, this is one of the most splendid of all

the buildings in the Marais and one of the best preserved of this period. We owe its good condition to the fact that it was restored and modified in the middle of the seventeenth century by François Mansart, otherwise it might well have been demolished like so many other Renaissance houses. In its original form, the main part of the building was on two floors at the back of the courtyard and was decorated with fine sculpture by Jean Goujon. The side wings and the façade overlooking the street were only one storey high. Although the present entrance porch dates from the sixteenth century and the sculpture is by Jean Goujon, the rest of the façade is by François Mansart. The fine statue of Louis XIV by Coysevox, now standing in the centre of the courtyard, was brought here from the Hôtel de Ville. The main part of the mansion, at the end of the courtyard, is in late Gothic style with Renaissance detail in the sculptures of the four seasons which were carried out under the directions of Jean Goujon. The large figures on the wings were executed in the seventeenth century. The buildings were considerably enlarged during the seventeenth-century alterations and by subsequent additions in the nineteenth and twentieth century.

The collection displayed in the Carnavalet is of more interest to historians than to painters since there are many works of art of outstanding merit. Nevertheless there are some fine old iron signs dating from the fourteenth to the nineteenth centuries, a number of attractive sketches and views of old Paris and souvenirs of famous men and women, some intrinsically beautiful, but many more of interest for the events they evoke. One of the rooms has a ceiling painted by Lebrun, and others are splendidly decorated and have beautiful panelling taken from demolished houses in the Marais. The painting of the Place Royale is of great interest, especially as this lovely square, now called the Place des Vosges, stands only a short distance away. Incidentally, there is a highly valuable library

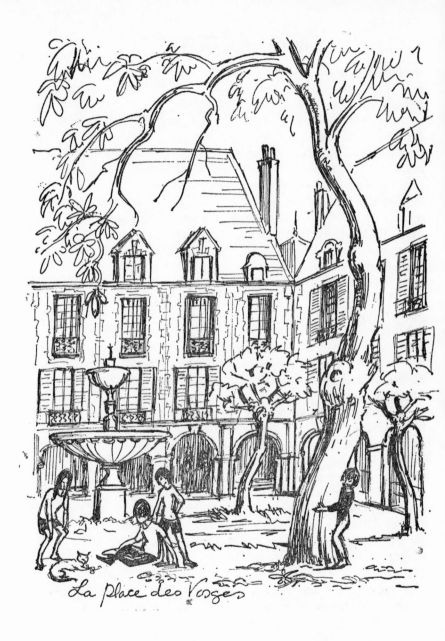

La place des Vosges

of reference works dealing with the history of Paris in the museum.

I have left the Place des Vosges till last in this description of a few of the buildings in the Marais, because it is, to my mind, the most attractive square in Paris, albeit a trifle forlorn, and with the nostalgic aura of past centuries. The houses have been cleaned and many of them restored to their original pale gold and rose pink, but the long arcades echo with the sound of individual footsteps and the gardens in the centre lack the gaiety of other squares, for even the fountains splash rather reluctantly, and the children play in dusty little groups. It must indeed have presented a very different spectacle when elegant women watched from the windows as splendidly clothed knights jousted on horseback.

The best approach is from the south along the rue St Antoine and then left down the rue Birague which leads you straight through the arcade of the Pavillon du Roi to the entrance to the gardens surrounding an equestrian statue of Louis XIII, a modern replacement of the original melted down during the Revolution.

The square was constructed under the orders of Henry IV in a patch of ground which he intended to turn into a fashionable parade. His instinct for good town planning made him insist that the houses should all be uniform in design. The Pavillon du Roi was intended as a royal residence, but it was never used as such. The arcades gave shelter from the weather to shops on the ground floor; carriage ways were reserved for carriages and riders and an open space was left in the middle for parades and spectacles and it was, in fact, at times used for duels. The square got its present name in 1800, since the Vosges was the first department to pay its taxes during the Revolution. Cardinal Richelieu lived at number 18 and Victor Hugo at number 6, where there is a small museum containing some of his possessions and a few manuscripts of his books.

Unless you want to lunch in the Place des Vosges itself, you will find a wide choice of restaurants and cafés in the Place de la Bastille. You will not meet any tourists here, but you may be lucky, on a Saturday or Sunday, and find a lively fair in progress. There is a large column in the centre to commemorate the Parisians killed in the revolution of 1830, but not a trace remains of the Bastille which was pulled down by the mob in 1789.

South of the Bastille there are more old houses and streets in the Arsenal quarter and there is even a museum—or rather a library—in what remains of the original arms store in the Boulevard Morland, containing a vast number of books on the theatre in a setting of seventeenth- and eighteenth-century furnishings and decorations. If you turn up the rue Mornay, you can see, in the Bassin de l'Arsenal, a picturesque display of brilliantly painted and decorated barges from all parts of Europe, complete with their owners' families and gay lines of washing.

If you are very much interested in ports and boats, this is the region where the Paris docks begin, and you will see boats of all sizes and description along the Seine. If this does not satisfy you, go northwards beyond the Bastille to the Place de la République and find your way to the Canal St Martin. This creates a largely underground link between the river at Austerlitz and the Bassin de la Villette, as it lunges eastwards to rejoin the Seine, thus cutting off a great loop of the river and shortening the route for the barges.

The most attractive part of this canal scheme is the portion between the Bastille and the Place Stalingrad and La Villette. Here the water, shaded by trees, flows right through the middle of the boulevard, with traffic on either side. Beneath the trees, old men and women, mothers and babies sit on benches, and fishermen quietly and optimistically wait for a catch. Signac made a wonderful painting of the canal, with trees and an iron

footbridge, and many contemporary painters have found it a good subject for a composition. It was in this district that the neo-impressionist, Georges Seurat, was born in 1859. He was the son of a bailiff at La Villette, and the family, although quite well off, lived in a dreary street, the rue de Bondy. It is true that it was not far from the St Martin Canal, with its general air of excitement, but that did not make up for the mean streets and drab populace. Seurat's father was a sinister figure. He had only one arm, but the stump was furnished with a hook, and he was most dexterous in its use. He came occasionally to the rue de Bondy, but he spent the rest of the time in a little place at Le Raincy which he termed his country house, although even then it was only on the outskirts of Paris. He filled this house with all sorts of worthless and sentimental images and statuettes. The basement became a kind of oratory in which, in his religious ardour, he conducted services. He lived alone here except for the gardener who helped him with the services as well as with the flowers which this strange man adored.

When Georges was born, the bailiff decided that the house in the rue de Bondy was no longer good enough, so he found a house in the Boulevard de Magenta, another dreary thoroughfare, this time near the Place de la République. He brought his furniture from the house at Le Raincy to the Boulevard de Magenta, but he was still unable to live in one house and used to go back to La Villette where his office was, and of course to Le Raincy. There was no question of his deserting his wife and living with anyone else. He simply preferred solitude to home life, at the same time taking full responsibility for his family and supporting them in comfort.

It was a strange and sad environment for a child. His mother was quiet and resigned to her curious existence and his father seldom stayed in the house unless he was ill.

This oddly assorted couple were undoubtedly devoted to

their son, for they gave him every consideration and help. His mother used to take him into the Buttes-Chaumont Park for she felt the house was gloomy and unhealthy for a child. During the Siege of Paris, when Georges was eleven years old, she took him with his younger brother and sister to the comparative safety of Fontainebleau.

It does not seem that Seurat showed exceptional talent for art when a child, and it was not until he left school at sixteen that his passion for drawing began to develop. His family were quite happy for him to take a course of study at the Municipal School of Art where he spent three years. It was there that he met his life-long friend Aman-Jean and three years later, the two young men joined the Beaux Arts under Henri Lehmann, a pupil of Ingres. They did not find the teaching very inspiring, so after a year's hard work, they decided to share a studio in the rue de l'Arbalète on the strength of Seurat's allowance generously provided by his parents.

Seurat and Aman-Jean were now living in a completely different quarter of Paris from the drab Boulevard de Magenta, and its gaiety and charm must have been a delight to them, for although they had spent a year studying in the Beaux-Arts in the attractive *Sixième*, both boys had passed most of their lives in the east end.

Instead of the Buttes-Chaumont, the painters could now stroll in the Jardins des Plantes, and the Luxembourg gardens (with children playing in the shaded walks) were not far away. Seurat was doubtless already observing the play of light and shade on moving figures, the reflections in the water and the appearance of groups of people gathered together in the open air. This Paris was not to be Seurat's inspiration for long, for he was due for military service which he spent at Brest, where he was much attracted to the ships and the sea. He drew masts and bales of ropes and all the paraphernalia of ships and shipping, during his periods of leave.

When Seurat left Brest, he took a studio in Paris in the rue Chabrol near his mother, who was still living in the Boulevard de Magenta, and most days he used to have his meals with her. Not even this uninspiring quarter prevented him from painting corners of Paris and the countryside nearby where he found so many subjects for study. It was on a visit to his mother that a sore throat he complained of developed into a violent fever and the painter was dead, at the age of 31, almost before anyone knew his was ill.

The Parc des Buttes-Chaumont is to the east. This east end park is one of the loveliest and one of the least-visited open spaces in Paris—that is to say, the least-visited by anyone but Parisians of the immediate vicinity, for as in most Paris parks, there are cafés and restaurants and all sorts of diversions, including Punch and Judy shows, donkey rides, goat cart trips and roundabouts.

The park is laid out on a steep slope formed by a disused quarry and is believed to have been designed from plans by Napoleon III. In the middle of the gardens the waters of an artificial lake surround a high crag surmounted by a temple from which there is a widespread view towards Montmartre and the Sacré Coeur. But these are only the obvious attractions, for you can wander in deep woods, follow secluded paths, walk beside sweeping green lawns or sit in sheltered arbours, and there are always a great variety of ducks and swans to watch and to feed.

Walk south through the Belleville district if you want to see something of René Clair Paris, for this is the background to many of his films; not spectacular but with the right scenic effects, the small cafés, the street merchants and the amusing characters who are very much individuals. Quite a number of painters choose this part of Paris for their studios; maybe even at the top of some of the hideous blocks of flats, for the air is good, the view of Paris quite miraculous and all the move-

ments of the street scene flows below. It is not all composed of concrete blocks, for these are interspersed with an old cottage or even the remains of a farm building.

If you are here on the 14th July, the inhabitants really know how to enjoy themselves, and dance to the music of bands and barrel organs, in the streets where cafés and bars are open all night.

Most people like to make one visit to the cemetery of Père Lachaise, if only to see Epstein's tomb of Oscar Wilde, but there are so many other famous people buried here that the only solution for finding the way about this immense place is to buy or consult a plan at the entrance gate. Unless you like an aura of deep depression and gloom, do not come here on the *Jour des Morts* (All Saints Day) at the beginning of November when most of Paris dresses in black and goes to visit the cemeteries.

VII

THE WEST END

PALAIS ROYAL – BIBLIOTHÈQUE NATIONALE – THE OPERA –
SMALLER MUSEUMS – PARC MONCEAU

WESTWARDS from the Marais the Right Bank slowly
becomes less down-at-heel and more sophisticated
and fashionable but, to the north of the Louvre, there
is still a quarter with some rather sorded streets until you
approach the distinguished area of the Place Vendôme, the
Jardin des Tuileries and the Place de la Concorde.

However, it is worth while taking the quays in a leisurely
manner, more especially the Quai Mégisserie; for one thing,
from this quay you can see the ancient houses on the Ile de la
Cité and on the Left Bank, but it is also lively with the chirp-
ing of canaries and brightened by the vivid colours of exotic
birds. Almost every shop is a birdshop and cages crowd the
pavement. It is always a delight to sit at one of the café ter-
races, looking across to the Pont Neuf and the statue of Henry

IV, who rides his splended charger above the glittering prints on the bookstalls, against a background of trees and the dome of the Panthéon. It is not far to walk northwest from here to the Palais Royal and its gracious, dignified arcades round formal gardens. It is perhaps just a shade melancholy, although on a sunny day, it is very pleasant to sit here, away from the noise of the traffic and the bustle of the streets outside. In summer, the bare stone pavings and the long colonnades are relieved by flowers and shrubs and the sound of splashing fountains. Since the stone has been cleaned to a warm pale gold, the atmosphere has become very much more cheerful.

The Palais Royal was originally built for Richelieu who left it to the royal family and eventually Philip of Orleans' son, who acted as Regent for Louis XV, rebuilt it and turned it into a centre for the dissolute life of Paris. It was his grandson who commissioned Victor Louis to build the arcaded quadrangle round the garden—an architect who also built the Théâtre Français which still stands in the delightful square of the same name, a busy square, but fascinating at night in the gleam of lamps and sparkle of fountains splashing into stone basins held up by *putti* garlanded in flowers. The theatre of the Palais Royal on the north of the square was built in the eighteenth century and the interior and proscenium are very beautifully decorated with roses and nymphs and garlands, in velvet and gilt; it is now devoted to the production of light operas and gay musicals.

The eighteenth-century fashionable portrait painter, Elisabeth Vigée Lebrun, has many associations with the Palais Royal and the surrounding district. She was born in the rue Coq-Héron in 1755, and she herself wrote vivid accounts of the Paris of her time, and especially of this quarter. She came of an artistic family, for her father was a popular pastel portrait painter, a lovable character who, on New Year's day, used to rush about all over Paris, kissing every girl he met, and

wishing her a happy New Year. He gave the gayest and most amusing of parties to his painter and writer friends and, even though the young Elisabeth probably did not understand much of the witty conversation, these evenings set the pattern for the brilliant gatherings over which she herself presided in later life. She developed a passion for painting when she was still a young child, and this was, of course, very much encouraged by her father. At his death, which occurred when she was still young, she was so overwhelmed with sorrow that she refused to paint until one of her father's elderly friends took her in hand and persuaded her to paint portraits. She sold enough of these to keep up the house and even to educate her brother.

Elisabeth was not only talented but very lovely and she soon became successful though she was unhappy when her mother remarried a rich and insensitive jeweller who was extremely mean, and the family moved into his house in the rue St Honoré overlooking the Palais Royal. She was, of course, fascinated by the wonderful collection of Italian pictures in the Palais which had been collected by the Regent, and longed to visit Italy. These paintings were sold to an English collector during the Revolution.

When Elisabeth used to walk there with her parents after Mass on Sundays the gardens were much more elaborate than they are today; a wide walk stretched on either side, shaded by high trees—a promenade where the wealthy showed off their luxurious clothes, watched by the humble populace who peered at them from the sidewalks. The young girl's good looks attracted the attention of the rich and fashionable and her talent soon gained her many more commissions.

When Elisabeth married Lebrun and went to live in the rue Cléry, she changed her name to Elisabeth Vigée Lebrun keeping her maiden of Vigée. Her husband was a gambler and always in debt, but he had a good gallery of paintings. Never-

theless his need for money was so great that he even forced
his wife to run a painting school. She found this work extremely
tedious and soon gave it up when well-paid commissions be-
came more and more numerous. Although Vigée Lebrun was
a talented and popular painter, her work is rather slick and the
portraits are too flattering and sweet for modern tastes. She
inherited her father's liking for gay company, but her parties
were rather forced in their effort to be exceptional. She once
gave an Athenian supper, dressing her friends as Greek person-
alities in the draperies she kept for her sitters. She arranged
priceless Etruscan vases on her shining mahogany table and,
since she always affected a loose Greek gown she had only
to place a crown of flowers round her short, loose curls to look
like a beautiful Greek. Her cook made Greek sauces for the
dishes that were served, and the guests were entertained by
Greek choruses accompanied on the lyre.

During the Terror, Vigée Lebrun was subjected to a great
deal of persecution, and the revolutionaries even threw sulphur
into her cellar. She was so distressed that she took refuge with
a friend in the Invalides district, and with great difficulty
eventually managed to escape from the capital; this led to the
beginning of her extensive travels to Italy and further afield.
She even spent a few years in England. She finally returned
to France where she died at the age of 87.

The rue des Petits-Champs, at the north of the Palais Royal,
will take you to the Place des Victoires—a circus built in the
seventeenth century by the Marquis de la Feuillade in order to
ingratiate himself with Louis XIV. The equestrian statue of
the King was destroyed during the Revolution but was replaced
by the present one, shortly afterwards. The beautifully planned
buildings in this circus have been restored by the Ministry
of Fine Arts, but they were so dilapidated that only a few years
ago they were nearly demolished. Near to the Place des Vic-
tories you will discover a number of fine houses, some with

carvings over the doorways, which now are mostly connected with politicians.

Closeby to the north, you will find the Bibliothèque Nationale which is well-known as one of the largest and most complete libraries in the world, but perhaps not so well-known as a splendid museum: for it houses the Cabinet des Médailles which specialises in Greek and Roman antiquities, statuettes, vases, ivories, and gold and silver jewellery, and dates back to medieval times. It was once known as the Cabinet du Roi, since it housed jewels and other *objets d'art* amassed by Kings of France. Its most prized possession is the ancient throne of Dagobert who was king of France in the early seventh century, but there are also Etruscan necklaces, Byzantine ivories, rare antique jewellery, medals and cameos.

Special exhibitions of some of the treasures from the Cabinet des Estampes and the Cabinet des Manuscrits are arranged from time to time in the Galerie Mansart on the ground floor, but these collections are not normally on view to the general public.

If you walk northwards from the Bibliothèque Nationale to the busy Boulevard des Italiens, which derives its name from a company of actors and which Pissarro painted with such a magical touch, and turn left along this busy, tree-lined thoroughfare, you will arrive at the Place de l'Opéra which is still, in a sense, the real hub of Paris, and the busiest square of the whole capital; and the famous *Café de la Paix*, though no longer the haunt of fashionable Parisians, is still a good place from which to view the street scene. The Opera House itself impresses rather by its size and elaboration than by its beauty, since it was built in the rather doubtful taste of the mid-nineteenth century. Even so, it is worth a visit for the splendour of its staging, its foyer and its auditorium and, of course, the really grand staircase. On a gala Friday night, the brilliant scene is enhanced by the soldiers of the *Garde Républicaine*

lining the stairway in their shining helmets and drawn swords. There is even a small museum exhibiting objects which belonged to famous actors and singers.

This is the area of fashionable department stores selling high-class goods, although not in the luxury range, and of cafés and teashops frequented by the well-to-do, especially along the Boulevard de la Madeleine and the Boulevard des Capucines. In this last street you will find an appropriately elegant collection of furniture in the Musée Cognacq-Jay, in the house of a certain Monsieur Cognacq who was the original owner of the vast and popular Samaritaine department store and who lived here, with his 'cherished companion' of the name of Jay. Between them, they collected the most delightfully frivolous furniture and *objets d'art* of the eighteenth century, chosen for their charm and lightness rather than their claim to be great art, but amongst them you will find the works of such outstanding painters as Watteau, Reynolds and Gainsborough. You will, naturally enough, find a portrait by the fashionable Vigée Lebrun. The Cognacq-Jays, as they called themselves, also collected Louis XV furniture and luxurious silks and velvets—almost anything gilded and garlanded of a delicate charm.

Directly north of the Opera House, you will reach the Boulevard Haussmann, named after the nineteenth-century prefect who cut the wide boulevards through the city, demolishing many ancient streets. The streets in this quarter are just a shade gloomy, the buildings having no particular architectural attraction, though they seem to have suited some artists, for it was here that, in the late nineteenth century, Puvis de Chavannes and the poet Mallarmé had studios. The boulevard itself is of great interest to painters if only for the fact that the Jacquemart André museum is here. The mansion in which it is housed was built towards the end of the nineteenth century, for Edouard André married the artist, Nellie Jacquemart, and

together they acquired the splendid collection which was
eventually left to the nation. The rooms themselves are rather
florid, but they are spacious and well-proportioned, which
they need to be for this very large collection. Unless you have
days to spare and are a specialist, it is best to pick out the
exhibits of outstanding worth, for there are some really beauti-
ful and rare things to be found, and the small *objets d'art* are
particularly well displayed.

Do not miss the lovely early fifteenth-century Flemish Book
of Hours and more especially, the superb illustration of *The
Visitation*, set in an enchanted landscape and surrounded by
a delicately flowered border. There are also some small por-
traits by the school of Clouet and some sixteenth-century
French bindings. Among the oil paintings are fine portraits by
Rembrandt, Van Dyck and Rubens.

The museum possesses a collection of Italian Renaissance
art of great interest to the specialist because it is represented
by lesser-known masters of painting and sculpture as well as
a *Madonna and Child* by the fifteenth-century Baldovinetti,
and there are several seventeenth-century Florentine portraits,
a Carpaccio and some Crivellis. The main Renaissance room
is decorated in fifteenth-century style, with a painted Florentine
ceiling, a Venetian fountain and a sixteenth-century doorway.
This atmosphere is enhanced by the beautiful *cassone* around
the walls—the Italian chests so brilliantly decorated by contem-
porary artists.

Among the many examples of enamel work and pottery,
jewels and statuettes, painted screens and small and large
pieces of furniture, are some very rare pieces and there are also
some very good series of drawings which are mainly French
and of interest to the specialist.

When you are in this district, you will hardly be able to
avoid seeing the enormous mass of the garishly ugly church
of St Augustin; it is indeed ugly but its cast-iron dome stands

out against the sky and is one of the accepted landmarks of Paris.

The Boulevard Haussmann becomes busier as it goes east-wards and is mainly of interest for its large department stores, the Printemps and the Galeries Lafayette, both of which sell moderately priced goods in great variety. To the north lies the Quartier de l'Europe which is extremely dull, ugly, noisy and monotonous and overflowing with people and traffic at all times of the day and night. Nevertheless many painters found inspira-tion here and, more especially, around the Gare St Lazare. One obvious example is Monet's lovely painting of the inside of this main station, the cast-iron interior of which is so beauti-fully designed as to be the best architectural feature of the area.

Manet also had his first studio in this area, where he worked and stored his paintings, which piled up quickly enough since scarcely anyone would buy them. It was not a very romantic place, but just a large shabby room in a district mostly occu-pied by warehouses and patches of wasteground but the whole quarter has since been entirely transformed and there is noth-ing left of its former character. The painter did not entertain here, apart from receiving his intimate friends, for he was sufficiently well off to have a separate establishment where he could lead the distinguished social life to which he was accus-tomed. Nevertheless he spent a great deal of time in his studio and worked extremely hard.

Manet was the son of a high official in the Ministry of Justice and was brought up in an atmosphere of ancient tradi-tion in St-Germain-des-Prés when it was still a quarter of large private mansions, although even at that time many painters and writers rented studios there. His parents were anxious for him to take up the law and were very much against his becom-ing a painter, so Manet decided to go to sea rather than to conform to their wishes, but he was certainly not a success as a sailor. He did not succeed in his examinations and was refused

admission. His father looked on his son as a failure and was finally persuaded to allow him to study painting at the Beaux Arts, and as soon as he had completed his course, he took a studio where he could work undisturbed.

Although his individual and direct approach was apparent in his painting, he was still only a very gifted student and showed the influence of one school after another. He continued to copy the old masters as he had done at the Beaux Arts but also to paint contemporary characters—the ordinary people he saw around him rather than professional models. It was these subjects which preoccupied him more and more such as the portrait of the *Boy with the Cherries* and the *Buveur d'Absinthe* which was certainly a character study and not in any way idealised. In these paintings he was still finding his way and had not yet struck out into the brilliant style for which he was so much criticised but for which he later became famous. His paintings of the Paris we know today, include the *Musique aux Tuileries* in the Courtauld Institute, London, which though it reveals his genius in the quality of painting, is more an interesting record of the time than an inspired production; and the *Bar of the Folies Bergère* which was actually exhibited at the Salon and was criticised mainly for its subject matter, a subject which in its naturalness appeals to our present day taste far more than to that of the late nineteenth century. The lovely, wistful face of the girl, the glowing skin set off by the dense velvety blackness of the dress, the glitter of the bottles and the brilliant coloured fruit, together with the atmosphere of the footlights, give the painting an extraordinary attraction. Manet succeeds in presenting the girl's reflection in the mirror and in giving us two views of the bar interior without confusing the dramatic force of the picture.

This canvas—the last that Manet was to show—was painted under terrible stress. He was seriously ill and had great difficulty in working; and after the Salon, he went to spend the

summer in the country. There he made sketches of the garden and the flowers. His illness was incurable, and although his gangrenous leg was amputated in an attempt to save his life, blood poisoning set in and he died in Paris in the spring of 1883.

Manet is famous for the number of portraits he has left us, of both men and women friends, many of whom were celebrities. In 1876 he painted the poet Mallarmé and the portrait has an impact on us as though we were in the room with this enchanting personality. We can picture the friends together, the poet having stopped at Manet's house on his way home from his job as a teacher.

Unlike the Impressionists, Manet did not live in the artists' quarters, but inhabited the more conventional districts; so he was buried in the distinguished suburb of Passy, and round his coffin were six of the most distinguished friends that any painter of his time could have had as a guard of honour : Antonin Proust, Théodore Duret, Fantin-Latour, Claude Monet, Alfred Stevens and Emile Zola. Degas, deeply affected by the death of his friend, followed the funeral cortège and made the simple remark : 'He was greater than we thought.' George Moore tells us that for many years Mary Laurant, the beautiful mistress of more than one distinguished man, took the first lilac of the spring to lay upon his grave.

Manet must often have walked in the Parc Monceau, one of the most delightful parks in Paris. Originally part of the ground of a shooting box belonging to the Duke of Orléans, it was laid out in the fantastic style of the eighteenth century with follies, Roman temples, a farm and even the fictitious remains of a medieval castle. It was completely remodelled in the popular English style when it became a public park during Napoleon III's reign but some of the features remain, including the romantic lake with its classical colonnade. In common with most of the open spaces in Paris, these gardens are full of

statues, of no great artistic merit but pleasant enough features as they contrast with the dark foliage and bright flower beds in the summer. In the nineteenth century, the Parc Monceau was in the smartest quarter of Paris, but it is still a playground for prosperous children, who go there to enjoy themselves quietly with their nurses and families.

Around the gardens on all sides are the spacious, luxurious houses of the rich, at least two of them being of particular interest to artists : firstly, the Musée Nissim de Camondo and secondly, the Musée Cernuschi, in the Avenue Vélasquez. The first of these was originally the collection of the Comte Moïse de Camondo who had the family mansion completely re-modelled in the style of the Petit Trianon at Versailles. When this was completed, he concentrated on furnishing it with the most beautiful examples of eighteenth-century furniture and ornaments that could be found, and on decorating it in the same style. He spared no effort and no cost in satisfying his passion for the beautiful things of the period, and he would patiently wait for years to acquire a perfect work of art rather than make do with a substitute.

The whole museum as it stands today is arranged as the Count originally designed the rooms, and the result is a perfectly appointed house with the most exquisite and rare works of art, all of the same period. The craftsmen and artists whose works he chose, were the best in their field; he obtained tapestries from the Gobelins and Beauvais looms, Aubusson carpets, fine silverware and Sèvres porcelain. He even bought up the panelling and mirrors from demolished mansions to get the right effect. The whole setting is so complete and perfect that the Ecole des Arts Décoratifs is directed from this museum.

The Musée Cernuschi in the small Avenue Vélasquez, is entered through a splendid iron gate, and houses a superb collection of the art of China. It was originally a private collection but it has been considerably enlarged and now offers

a complete survey of the development of Chinese art and more especially, of ceramics from 2,000 B.C. The fact that this is not a very large collection enhances it for most visitors, since there is time to look at almost everything and with especial interest at the highlights, the beautiful elegant Bodhisattva, the figures of the Han dynasty, the eighth-century bronzes with their green and blue patina, and the elegant bronze deer. There are even examples of modern work so that we can trace the recent influence of western art and the changes it has wrought in oriental art.

VIII

THE MAJOR MUSEUMS

Musée du Louvre – Musée des Arts Decoratifs –
Musée du Jeu de Paume – Musée de l'Orangerie – Le
Petit Palais – Musée Guinet – Musées d'Art Moderne –
Musée des Monuments – Musée de l'Homme – Musée
de la Marine

THE major museums of particular interest to the painter
are all on the Right Bank and within reasonable distance
of each other. I am not however suggesting that it would
be possible or desirable to visit more than one or, at the most,
two in a day. Of these, it is obvious that the Louvre is of para-
mount importance, backed up with the Impressionist paintings
at the Jeu de Paume and the huge collection in the Musée de
l'Art Moderne.

The Louvre is, of course, much more than a museum, for it
is a splendidly appointed palace containing several different col-
lections in its many wings, and is situated in one of the most
impressively planned complexes to be found in Europe.

To stand by the Arc de Triomphe du Carrousel between
the two *pavillons* of the Palace and look towards the Tuileries

gardens, is one of the greatest experiences of a first visit to Paris. At any season of the year, at any time of the day or night, this miracle of spacious planning is a visual delight. In spring and throughout the summer, the formal gardens are brilliant with flowers and the regular pattern of lawns and individual gardens is broken by fountains and pale statues appearing out of the trees which are so varied in their different greens and yellows as to make a kind of tapestry background. Beyond the gardens the obelisk in the centre of the Place de la Concorde cuts straight across the Arc de Triomphe de l'Étoile at the top of the rise of the Champs-Elysées which are flanked by blossoming chestnut trees.

The Palace of the Louvre dates from the middle of the sixteenth century when Francis I had an old fortress demolished and commissioned Pierre Lescot to build a palace in its place. For twenty years the architect worked on this project with the help of the sculptor, Jean Goujon, and finished practically all the southern wing as well as the south-eastern section of the great courtyard before his death at some point between 1564 and 1568. This part of the Louvre has been very little restored; the remainder of the western wing of the main courtyard was built during the reign of Louis XIII and the whole structure was completed under Louis XIV. Needless to say, he had grandiose plans for the building including asking Bernini to produce magnificent designs. For some reason, Bernini's ideas were not found acceptable and it was Perrault who finally planned the eastern front known as the Colonnade. Shortly afterwards, the court was transferred to Versailles and the Louvre was abandoned as a royal residence; it was taken over by squatters of all sorts but more especially by sculptors and painters who established studios in the vast rooms. The space between the Tuileries, the palace built for Catherine de Médicis, but burnt down in 1871 and the main quadrangle was at that time filled with squalid streets where the buildings

quickly fell into decay. It was Napoleon I who finally cleared out the space and built the graceful Arc de Triomphe du Carrousel in commemoration of his victories, and also as a monumental entrance to the Tuileries. The southern arm of the Louvre had already been extended and Napoleon began the building of the north side but this was not completed until the reign of Napoleon III. Since the general lines laid down by Pierre Lescot were followed, there is absolute harmony in the planning and decoration of the whole building, although it took some 300 years to complete.

From all accounts, the Palace of the Tuileries was not particularly beautiful and its disappearance is a great advantage since its continued existence would have blocked the splendid vista up to the Arc de Triomphe.

As for the museum itself, it needs at least three visits to get any idea of its more important collections, though one occasion might suffice for a look at the more famous paintings and Greek sculptures.

It must be remembered that in common with so many other important museums in the capitals of Europe, the Louvre is an extremely tiring place. There are seemingly endless corridors and staircases and it is sometimes necessary to walk a long way through less interesting galleries to reach the things you particularly want to see. Since the Louvre was built as a Royal residence and not specifically for the display of works of art, the first impression of some of the galleries can be disappointing to the uninitiated because of the absence of facilities for display which make more modern galleries so attractive. The rooms themselves are very beautifully designed for their original purpose and the long windows give welcome glimpses of the courts and gardens.

It is obvious that any student of the arts, on a short visit, will know exactly what he wants to see among the outstanding works. Even the layman will want to study the sculpture of the

Victory of Samothrace, which can scarcely be missed as it stands magnificently poised at the dividing of the main stairway, the *Venus de Milo* and the archaic *Hera of Samos*, the Parthenon sculptures, the *Winged Bulls* from the Palace of Khorsbad and the inscrutable *Seated Scribe*.

Among the French paintings, everyone will want to see François Clouet's portrait of *Francis I*, Watteau's magical *Embarkation for Cythera* and Géricault's dramatic *Raft of the Medusa*. So many arrows point to Leonardo's *Mona Lisa* that it would be impossible not to find it and *The Virgin of the Rocks*—this latter being of particular interest, quite apart from its intrinsic beauty, as the painting in the National Gallery, London, is a later version of the same theme. This also applies to the Uccello Battlepiece since it is the right hand panel of a triptych, the centrepiece being in the Uffizi and the left hand panel in the National Gallery.

Of the other outstanding Italian works, I would suggest Cimabue's *Virgin with Angels*, Giotto's *St Francis*, Mantegna's *Crucifixion*, the delicately beautiful *Virgin and Child* by Baldovinetti, Ghirlandaio's portrait of *An Old Man and his Grandson*, and the *Fête Champêtre* by Giorgione which inspired Manet's controversial painting, *Déjeuner sur l'Herbe*. Among the greatest Italian portraits are Titian's *Man with a glove*, Raphael's *Balthasar Castiglione*, and the decorative early painting by Pisanello of *A Princess of the House of Este*.

In the Spanish school, El Greco's *Ferdinand of Spain* and Velasquez's *Queen Marianna* are major works of their respective painters and in the Dutch section you will find superb compositions as well as portraits by Rembrandt, and Vermeer's famous *Lacemaker*; among the German works are the *Self-portrait* by Dürer, and Holbein's *Anne of Cleves*.

This may sound a ridiculously short list, from such a vast collection of masterpieces, but it may be sufficient for a first visit if you are also to spend time over the sculpture and keep

at least a quarter of an hour for the Galerie d'Apollon where the Crown Jewels, the remains of the treasure of St Denis and ceramics and enamels are displayed. Also the huge entrance hall holds a great deal of interest in its postcard reproductions, its transparencies and its excellent and reasonably priced facsimiles of sculpture and jewellery, especially the early rather barbaric gold and silver brooches and pendants which are so suitable for modern use.

Since there is not as yet a catalogue of the Louvre collections, the serious student of art would do best to buy the general plan of the Museum or at least to consult the large one on show in the main entrance Hall and to confine himself to one section or part of a section for each visit. There are excellent courses which can be followed (see Appendix) and free lectures in the different departments. As a general guide, when planning your itinerary, the following information may be helpful. The department of Greek and Roman Antiquities is to the left and nearest to the principal entrance : architecture, sculpture and mosaics are shown on the ground floor, whilst bronzes, ceramics, jewels and Etruscan art are on the first floor. To the right of the Greek section you will find Egyptian architecture and sculpture, and smaller works of art are on the first floor. The main collection of Near Eastern antiquities occupies the rest of the ground floor on this side and Moslem art is to be found in a small section above. La Grande Galerie, on the first floor, is devoted to paintings of the European schools and, adjoining it, the Galerie d'Apollon contains the Crown Jewels. The rest of this floor, not taken up with antiquities, displays works of art of the Middle Ages, Renaissance and Modern Times and, hidden away on the ground floor, far to the right of the main entrance, a department of medieval, Renaissance and modern sculpture. As you will realise, this is a formidable challenge for a short visit and amounts to six separate collections of major importance.

Even the specialist may not have such a great deal of time to spare, so I would make a few suggestions of works of art he would be loathe to miss, over and above the exhibits mentioned earlier.

Three small rooms, down steps from the Greek department, exhibit works from Transjordania, Palestine and Syria which can be examined in almost complete solitude, and upstairs there is the fascinating statue of *Ebihil* (3,000 B.C.) who wears what looks like a quilted skirt—a strange character who gently smiles although his eyes are piercing, being inlaid with brilliant blue stones. In the room beyond are *objets d'art* from Susa in Persia which include jewellery as well as the delicate winged ibex of silver inlaid with gold, thought to be the handle of a vase. The Queen of Susa herself is represented by a bronze statue and there are other bronzes dating back to the twelfth century B.C. In the room of the Winged Bulls, there are cases of gold, silver and bronze objects.

Upstairs, through the room with the *Seated Scribe*, is the famous *Stele of the Serpent King*, of the Archaic Epoch, with the relief figure of Horus.

There is so much to see in the Galerie d'Apollon that this room really needs a special visit. The treasures include the crown of St Louis, Louis XV's coronation crown, the twelfth-century 'Sword of Charlemagne', and vases of rock crystal and lapis lazuli as well as fantastic treasures of ecclesiastical art.

The following room, the Salle des Bijoux has more jewellery and silverware. The rooms displaying an important collection of Greek and Etruscan pottery are mainly of interest to specialists in this field, but the Room of Bronzes has superb Etruscan jewellery, miniature Greek bronzes and mirrors and includes the little 600 B.C. statuette of Apollo and *Head of an Athlete*, a perfectly preserved example of Greek art of the fifth century B.C.

I cannot enumerate even the greatest paintings here, but time should be found for the second floor, with its less important works and also for the beautiful painted and carved statues in the sculpture section on the ground floor, in particular the twelfth-century Romanesque *Head of Christ* from the Loire and, in the Renaissance rooms, Michelangelo's *Slaves* which formed part of the scheme for the tomb of Pope Julius II.

There is yet another museum in the Louvre, quite separate although housed in the same building Le Musée des Arts Décoratifs is entered from the rue de Rivoli and is the Pavillon de Marsan, the north wing of the Louvre.

There are only two floors to be covered, since the ground floor is reserved for temporary exhibitions and the third floor is not, as yet, arranged. This is the museum for the leisurely person who enjoys wandering around the Victoria and Albert museum in London and seeking out rare and lovely treasures which he longs to possess, for indeed although there are many objects of ecclesiastical art, there are also exquisite pieces of furniture and *objets d'art* dating from the Middle Ages to the present day : silver and gold candelabra wrought in the seventeenth and eighteenth century, exquisitely decorated chairs upholstered in silk, little enamelled boxes in beautiful colours and, one in particular, fifteenth-century gold and mother-of-pearl, inlaid with a mosaic of pale-coloured stones with painted *fêtes champêtres* in panels. The mid-eighteenth century Venetian commode is gilded and inlaid with bouquets of flowers painted on a pale green background. There are figurines and goblets of crystal, delicate Persian paintings, and among the religious art, a delightful version of the *Entry into Jerusalem* painted at the end of the fourteenth century and part of a series of six depicting the Life of Christ.

To reach the more modern galleries of the Jeu de Paume and the remodelled Orangerie, you will have the delight of wandering through the Tuileries Gardens, for they are situated

at its far end, almost at the Place de la Concorde. These gardens were laid out for Louis XIV by Le Nôtre—the architect who designed the gardens of Versailles. At either end of the main alley of the gardens, there is a pond with a fountain where small children sail their boats.

Around these ponds, making up for the bare gravel of the promenade, are brilliant beds of roses, a miracle of colour in the early summer, and smooth lawns kept to perfection and rigidly guarded against trampling feet. The trees are in great variety, and in every alley there is the pale gleam of statues, many of them only remarkable for their decorative effect but some are real works of art. In 1963 a whole series of statues by Aristide Maillol (1861–1944) were installed in the gardens and include bronze standing figures cast in the early part of the century. To date, there is no indication of these superb pieces of sculpture and you will have to trust your knowledge of this artist's style and seek them out for yourself.

The Tuileries have a great attraction for children for, as well as having all the amenities of the other parks of Paris, there are unobtrusive cafés and a *Grand Guignol*. The sparrows, too, delight children and adults for they are unusually tame, and it is quite a normal sight to see bird fanciers literally covered with sparrows perched on their heads and arms, clamouring to be fed.

The Jeu de Paume is entirely devoted to the paintings of the Impressionists, and since they are admirably documented in the gallery itself, it would be superfluous for me to describe them here. The exhibits are very well arranged to show clearly the development of the movement, and no one could hope for a clearer account of the history of Impressionism and the different techniques employed than that given by diagrams, documenation and biographical notes as a preliminary to studying the paintings themselves.

The Jeu de Paume was originally built as an indoor tennis

court in the mid-nineteenth century; it later became a picture gallery but the lighting and conditions were found to be so bad that it was closed in 1954 and vast sums of money were spent on installing heating, modifying the lighting and reducing the window space to make it the splendid modern museum it is today. In fact it was almost entirely rebuilt.

Opposite the Jeu de Paume, the Orangerie has for many years housed panels by Monet in the *Salle des Nymphéas* and has also devoted a good deal of space to temporary exhibitions. Like the Jeu de Paume, the museum has been done up and prepared for a fabulous collection of modern art which has already been shown but is not yet on permanent display. A catalogue has been prepared and will doubtless be available when the collection is finally open.

Two groups of horses by Coysevox stand at the western entrance to the Tuileries and correspond to the more famous pair opposite, which gave entrance to the Champs-Elysées. These are the horses of Marly by Nicolas and Guillaume Coustou, so called because these prancing wild horses with glowing manes and tails were originally erected at the Château de Marly and only installed in the Place de la Concorde in 1795.

The short Rue Royale on the north side of the Concorde leads to the church of the Madeleine, a rather heavy handed attempt at a Greek temple with nothing to recommend it save its fashionable congregation on Sundays and its picturesque appeal when surrounded by the flower market held twice a week.

A nerve wracking crossing of the square to the south west and then a calmer walk along the Cours la Reine, will bring you to the two elaborate wedding cake buildings of the Grand and Petit Palais. The former is mainly used for large temporary exhibitions such as the Antique Fair and art shows, and the latter has a little-visited but fabulous collection of works of art, left to the city by a variety of collectors. These are not

always all on show as some exhibits have to be stored during temporary exhibitions, for Paris, like every other capital, lacks space for all her works of art. The main contributions were made by the brothers Dutoit and Edward Tuck, an American who lived in Paris, and include Egyptian and Etruscan art, bronze figurines, some with delicate green patina, terra cotta groups and collections of antique coins, as well as a rare collection of medieval art, with exquisite thirteenth- and fourteenth-century ivories, a wonderful little reliquary of the twelfth century, decorated with champlevé enamel on copper, fifteenth-century altar-pieces painted in infinite detail and some fine illuminated manuscripts.

It is not far to walk from the Cours la Reine to the group of museums situated close to the Quai de New York. Two museums of modern art are situated in the Avenue Président Wilson, the Musée Guimet at the Place d'Iéna and three more housed in the Palais de Chaillot which faces the Eiffel Tower on the other side of the river.

The Musée Guimet is entirely devoted to Asiatic art and it endeavours not only to provide a museum for the specialist, but also to present the art of these countries to the general public. There are regular lectures at weekends, free of charge to anyone who likes to attend, and guided tours take place on Mondays. Since this museum is arranged to be self-explanatory rather in the manner of the Jeu de Paume, there is no need to describe it further, except to say that no one interested in Oriental art should miss seeing the rare exhibits to be found there.

The two museums of modern art occupy separate wings of a large building in the Avenue Président Wilson, which was originally constructed for the 1937 exhibition. The Musée Municipal d'Art Moderne is installed in one wing and devotes a few rooms to the works of deceased modern painters, but the rest of the space is reserved for the important annual salons

at which you can study recent developments in art. The opposite wing houses an enormous collection of modern works dating from the later Impressionists and includes all the major movements in painting and the decorative arts, limiting its exhibits to living artists or to those who have died recently. It is admirably divided into sections so that you can see as much or as little as you like, yet can still obtain a complete idea of each period or school. It is constantly being added to and kept up-to-date, so a certain amount of re-arrangement is necessary from time to time.

This provides an excellent opportunity for the student to study the various trends of French painting, for every school is represented and a good selection of the leaders' works are on view. As in the Jeu de Paume, the names and dates of the painters are clearly given as well as a list of earlier artists who had any influence on the movement in question. In many cases this is augmented by documentation, photographs and letters. For instance, Picasso's work is shown in relation to the different stages of its development, and well-known and established painters such as Utrillo, Bonnard, Vuillard and Léger have separate rooms or niches devoted to them.

There are sections devoted to pottery and glass, stained glass, textiles and even furniture and schemes for interior decoration. Chagall's series of sketches for the stained glass windows at Metz Cathedral can be seen among his paintings and the Italian, Alberto Giacometti, is represented by some very fine pieces of sculpture.

The tapestry section is extremely interesting, displaying some of the brilliant designs which were on show in London a few years ago, illustrating the recent French renaissance in tapestry and in modern methods of dyeing and weaving. There is another section which shows designs by well-known painters which have been carried out in tapestry for upholstery, and space is given to book production and the various methods

employed in illustrating in colour and in black and white. In fact, every kind of art and craft is represented in this museum in such a way as to explain it to the average layman as well as being of incomparable value to the specialist.

The Palais de Chaillot, a little further along the river-side, is another building designed for the 1937 Exhibition. There had been an earlier 'palace' erected for the 1867 Exhibition—the extremely ugly Palais du Trocadéro which was not demolished until some time during the thirties, when everyone was delighted to see the end of this eyesore of red and yellow brick.

The east wing contains the Théâtre de Chaillot under control of the Comédie Française and also used for concerts and displays. Over and above this, it houses three separate museums of outstanding interest: the Musée des Monuments, the Musée de la Marine and the Musée de l'Homme. The Musée des Monuments is not very well patronised probably because it is a collection made up of casts and reproductions, but I cannot stress too much its interest for the student or even the specialist, since it makes possible a really detailed study of French architectural sculpture, mural decoration and stained glass in its various stages of development all over France and is of invaluable help both before and after seeing the originals.

The nucleus of the sculpture section was shown for many years at the old Trocadéro, but the grander scale of the Palais de Chaillot made it possible to carry out the present ambitious scheme of full-scale reproductions of many of the important carvings and frescoes in France, from early times until the nineteenth century.

You can walk through the portals of the cathedrals and compare them one with another and, since even the most widely travelled will have gaps in his knowledge of French architecture, this is an unique opportunity to compare different buildings.

The first room is devoted to casts of pre-Romanesque work, that is to say, Carolingian and Merovingian sculpture including the wooden gates of the cathedral at Le Puy. Then comes the Romanesque section with simple vigorous carvings from the Languedoc, Burgundy, the Auvergne and Provence. Another room is devoted to the art of the Crusades and then the Gothic rooms display the great glory of French sculpture in the cathedrals of Rheims, of Amiens and the portal of Chartres.

The casts get less convincing and less interesting as they become copies of buildings later in date. The copies of Romanesque and Gothic frescoes on the upper floor need a visit to themselves. Although every care is being taken of the Romanesque paintings all over France, they are inevitably deteriorating, so in order to keep a permanent record of them, full-size chapels, crypts and galleries were built in the palais de Chaillot and carefully lighted. Skilled artists were employed to copy the frescoes faithfully on to the walls of these structures, giving as nearly as is humanly possible, the effect of the original work.

The Marine Museum is well worth a visit if you are particularly interested in ships and the sea. It contains a fine collection of Joseph Vernet's sea pictures, many early paintings and prints and old maps as well as Napoleon's state barge, splendid in white and gold and green. However, do not spend time in this museum at the expense of the Musée de l'Homme in the same building. Most of the capitals of Europe are finding that both students and the general public are taking much more interest in their anthropological museums and this is certainly true of the one in the Palais de Chaillot. Art students spend a great deal of time here, drawing the exhibits and getting inspiration for designs from the simple, forceful works of art which are so much in line with modern taste. Personally I can never find time to see all that I want to see in these inexhaustible collections of native arts and crafts. There are

wonderful designs to be found in the masks, and curious carvings, in the gorgeous silver bracelets from Algeria and Egypt, and the brightly painted masks from Nepal. There are coarsely woven primitive cloths, materials from China and carnival costumes. Wonderfully imaginative theatre figurines come from Indonesia— *the Prince, the Princess, the Monster* and all manner of creatures. The enchanting votive horses from Japan in straw, in wood, in papier maché and ceramics are brilliantly coloured and full of imagination.

The range, diversity and originality of the exhibits ensures a great deal of interest for everyone.

IX

MONUMENTS AND MUSEUMS IN THE WEST

ETOILE – CHAMPS DE MARS – UNESCO – THE EIFFEL TOWER –
MUSÉE RODIN – LES INVALIDES – LA DÉFENSE – BOIS DE
BOULOGNE – MUSÉE MARMOTTAN – VINCENNES

OBVIOUSLY one of the most delightful things to do in the
way of comprehensive sightseeing in Paris, is to get an
over-all view of the city from one of the many vantage
points, and this becomes doubly worth while when time is
limited. I have already mentioned the views from Notre-Dame
and the Sacré Coeur but you will do well to supplement these
by others and more especially by the aspect of the capital
from the top of the Arc de Triomphe which gives an entirely
different view of the wide avenues stretching out like the spokes
of a wheel in all directions.

But first, let us consider the Arc de Triomphe as a monument
in itself, even though its virtue lies not so much in its design
and proportion as in its setting and magnificent situation. In
1806 Napoleon commissioned this enormous triumphal arch-

way to commemorate his victories, and it was erected on what is now called the Place de l'Etoile, the only site which could be found for it, but which, incidentally, also served as a gateway to Paris, since the fortifications at that date were established there. It was still unfinished when Marie Louise of Austria came to Paris, but a wooden frame and painted canvas gave it a semblance of its final aspect in order to welcome her. At Napoleon's defeat, many of his ambitious monuments were still unfinished and Louis Philippe, after he came to the throne in 1830, set about completing them so that when he negotiated the return of Napoleon's remains to France in 1840, he was able to organise a ceremonial procession to bear the coffin through the finished arch, which had been completed in 1831. Two years later, a great variety of sculptures were commissioned to decorate the archway with scenes of valour, the best known of which is the vivid relief by Rude, of soldiers surging forward, known as *La Marseillaise*.

The Arc de Triomphe has figured in many dramatic national events. It was opened for the passage of Allied troops in the Peace celebrations of 1919 and was the scene of great rejoicings in the liberation of Paris in 1944, but perhaps it is best known to English and French visitors for the tomb of France's Unknown Soldier and the Flame of Remembrance which is re-lit every evening. It is a most moving spectacle after dark, when the deep shadows under the broad arch intensify the brilliance of the flame as it flickers in the wind.

In the daytime, you can reach the top of the Arc de Triomphe either by a steep and difficult stairway or by taking a lift. From the platform there is a remarkable view of the spacious planning of the capital, and the twelve avenues converging on the Place de l'Etoile are one of its finest spectacles. Like so much of Paris, this quarter was developed by Haussmann, Prefect of the Seine, whom Napoleon III had chosen to re-design the city and to embellish it with thousands of trees

in many different areas. These avenues could be rather monotonous and very long if you are walking down them, but they are saved from monotony by the beauty of the trees and the gardens and grass verges. Before the coming of motor traffic, they witnessed magnificent scenes of pageantry, with elaborately designed carriages of all kinds, drawn by splendid horses or tiny ponies and perfectly groomed hacks ridden by elegantly dressed men and women.

Only the length of the Avenue Kléber separates the Arc de Triomphe from the Place du Trocadéro and the Palais de Chaillot. From the terrace gardens of this building, there is an especially attractive and planned vista over the Pont d'Iéna through the legs of the Eiffel Tower and down the green gardens of the Champs de Mars to the Ecole Militaire, commissioned by Madame de Pompadour to house the orphans of officers; and intended to outshine the Invalides. It certainly did not succeed in doing this as the dome is rather squat and the façade not very happily proportioned. It is now the Staff College.

Beyond the Ecole Militaire stands the very orginally designed Unesco building which could scarcely offer a greater contrast to the Ecole Militaire in the simplicity of its lines and more especially by the very modern and arresting mosaic by Joan Miró, an artist whose work is irresistible, despite the fact that it conforms to no particular movement; but the force and conviction with which he applies his rudimentary forms and his brilliant use of primary colour, is entirely satisfactory. Outside the building stands Henry Moore's *Silhouette at Rest* and the interior is decorated with murals by Picasso.

Naturally enough, the view from the top of the Eiffel Tower, given its height, is more extensive than from any of the other viewpoints, but it is much more apt to give the height-conscious vertigo than the broad platform of the Arc de Triomphe or the tower of Notre-Dame.

The building itself has rare elegance and shows a wonderful grasp of the use of cast-iron and, although to some it may look like a gigantic 'meccano' structure, to many it is a miracle of lightness and grace, tapering from its firm foundations in a golden-brown lace-work to its finial. Needless to say, there is a lift which deposits passengers at various levels. The tower was built by Eiffel in 1889 as part of the exhibition of that year, and was at that time the highest building in the world.

From Unesco, the Avenue de Ségur leads north to the Hôtel des Invalides, with its lovely gilded church, but this is best seen from the Esplanade and will be described later. Close by, in the Boulevard des Invalides, the Hôtel Biron houses the Musée Rodin, a collection which anyone interested in sculpture will not fail to visit, but it is also one of the most splendid mansions in Paris with a vast garden. Built in the eighteenth century, the interior decoration and ironwork are still intact and the house is beautifully proportioned and set well back from the road.

In the museum it is possible to make a complete survey of Rodin's work from its early days until the end of his life in 1917. Even his first attempts at painting are shown, as well as the sketches in clay he made for his finished works. On the first floor there are some enchanting little plaster and clay sketches of figures in action, studies for groups, and miraculous dancers full of energy and grace. Of the animal sculpture, *Le Lion qui Pleure* is a delightful study in marble and, apart from the obvious main works, there are powerful line and wash drawings full of movement.

In the charming garden there are a number of works by Rodin, including the famous *Thinker* which is set up in a rose garden. The enormous and complicated *Gates of Hell*, a massive bronze, completely lacking in grandeur, is a work which never really satisfied him although he made several

attempts at this commission for the gates to the Musée des Arts Decoratifs. The whole of the garden is open to the public, with its groves and fountains and statues, and its fascinating flower and kitchen gardens.

Apart from the statues I have mentioned, Rodin was responsible for a cinema façade which can still be seen in the Avenue des Gobelins and is described by Jean Dutourd in his delightful book, *Pluche ou l'Amour de l'Art*, crushed in by squalid houses, and boasts a pillared façade with theatrical masks and two voluptuous figures with palms.

This quarter to the east of the Invalides, is known as the Faubourg St Germain and is really an extension of St-Germain-des-Prés in the area to the west of the rue des Saints Pères; in the eighteenth century it was the most fashionable district in Paris. Even though most of the larger houses have been converted into flats, several of the old mansions are still occupied by noble families. The streets here are perhaps rather gloomy at first sight, for there are huge gateways with carved porticos and massive columns leading to spacious courtyards and sometimes even gardens. It is worth while going down the rue de Grenelle to have a look at the Fontaine des Quatre Saisons with its carvings and bas reliefs by the eighteenth-century sculptor Bouchardon. Continue down the rue du Bac to the Quai Voltaire and the Pont Royal, which is the oldest bridge in Paris, then stroll along the quay to the left, past the Chambres des Deputés to the Esplanade des Invalides and look down the wide expanse to the wonderful gilded dome of the church of the Invalides. Recently gilded, it is a miracle of grace from the outside, but the inside is mainly remarkable as the setting for Napoleon's tomb. The rest of the building is given over to the army museum. To me, it is always the ensemble of the Esplanade and the gilded façade of the church which is of such outstanding appeal at all times of the day and at all seasons of the year. I also have a weakness for the Pont Alexandre III which spans

the river opposite the Esplanade. Admittedly it is florid, like the Grand and Petit Palais, but it has a certain flamboyant exuberance as though it were a stage set for a gala performance, with its figures, its elaborate lamps and gildings; indeed it was designed, like the two palaces, for the 1900 Exhibition.

This Exhibition left a greater physical mark on Paris than any preceding or succeeding manifestation. The Exhibition of 1861 created the image of a gay Paris which has endured ever since, perpetuated by the operettas of Offenbach; the Exhibition of 1887 re-established France commercially, after the disasters of the Franco-Prussian war of 1870–1871 and the building of the Eiffel Tower asserted the value of modern technology, but the Exhibition of 1900 left its mark, with the Pont Alexandre III, the Grand Palais and the Petit Palais. The last great Exhibition in 1936, led to the establishment of the Palais de Chaillot on the site of the Trocadéro and the Musée de l'Art Moderne.

More recent development follows the expansion of Paris across the suburbs of Neuilly, the Seine and the Ile de la Jatte. This island is immortalised by Seurat's suberb painting *Sunday afternoon on the Jatte*. On the immense Avenue de la Défense there now stand the new exhibition buildings which were designed to serve as an impressive entry into Paris from the west.

The huge Palais des Industries is even more modern than the Unesco building, being entirely of glass, steel and concrete. It has, I believe, at the present moment, the largest roof in the world. It seems rather bleak and vast but doubtless, like all these buildings, it will gradually merge into its background. Its one great asset is that it is possible to reach it by driving through the ever attractive Bois de Boulogne.

Chaillot and Passy, now fashionable surburbs of Paris, were only villages in the eighteenth century, summer resorts where

people used to go to take the waters, but I do not believe that there are any springs left there now. The Champs-Elysées and the Etoile were surrounded by open fields and woods, but even in the present day, these quarters of Paris can hardly complain of being overcrowded or built up, since they are so near the huge open space of the Bois de Boulogne.

Until quite recently Passy retained the atmosphere of a French provincial town and even now there are one or two quiet, secluded corners. For instance, just off the rue Raynouard, the rue Berton is really a survival of village days, for it is a tiny cobbled street between walls which still enclose gardens. The back entrance to Balzac's house is in the rue Raynouard, a back entrance which he frequently used to escape from his many creditors.

Some of the houses in this quarter have views over the river and some directly overlook the Bois. At the end of the rue du Passy, the Jardins du Ranelagh were designed in imitation of the London pleasure gardens of the same name, and were fashionable in the eighteenth century for drinking and dancing. Now these gardens are mainly used by children who throng here on a Sunday afternoon to dig in the sand pits and play on the swings and see-saws.

The Musée Marmottan, just across the gardens, is one of the least known of the museums of Paris; it not only keeps its appearance of a beautifully furnished mansion in a delightful garden, but unexpectedly contains some extremely beautiful Impressionist paintings, more especially those by Monet. *The Train in the Snow* represents a blue-grey train puffing pink and grey smoke through the thick snow, with bare trees etched against the sky and the bright red 'eyes' of the train lending warmth and a strange radiance to the landscape. In contrast the *Tuileries Gardens* and the *Louvre*, in the green and blue and yellow of summer, have a gay, sunlit effect. This museum is only open on Sunday afternoons and is never crowded,

though it will not be long before the tourists come to see the legacy of a large number of Impressionist paintings, mainly by Monet, left to the museum by his son. At the moment many of these pictures have never been seen by the public and they are being stored until such time as sufficient money and suitable plans are found for an extension in which to display them.

From the Marmottan, you can cross the Boulevard Suchet and walk straight on into the Bois du Boulogne. This huge park is over 2,000 acres in extent and has some 60 miles of road. Napoleon III was responsible for its superb planning, for the roads, for the paths and the artificial lakes and islands set among the trees.

Early on weekday mornings, smartly dressed riders canter through the miles of bridle paths, but on Sundays and holidays the Park can be rather crowded. There are boats on the largest of the lakes and a café on the island. To the north, you will find the *Pré Catalan* restaurant which is in the luxury class, but meals are served outside and under the trees in the most attractive surroundings. To the west are the Cascades, an artificial waterfall with a café and restaurant nearby and a delightful place to sit on a warm summer night. Not far from here, the little park of Bagatelle, with its rose gardens and great variety of water lilies, can be visited for a small fee. This delightful park within a park, with *château* and lake, once belonged to the Marquis of Hertford and then to his son, Sir Richard Wallace. The city of Paris refused Sir Richard's collection of paintings which has now become the Wallace collection in Manchester Square.

The Jardin d'Acclimatation, best of the Paris zoos, is situated on the Neuilly side of the Bois de Boulogne. In some ways it is not quite so attractive as the Jardin des Plantes but it is much better kept, and is run by a private company.

Although the west end of Paris has the most famous and

fashionable of the city's parks, the south east has by no means been neglected, for the attractive Bois de Vincennes lies beyond the Porte d'Ivry. It was laid out on more or less the same lines as the Bois de Boulogne, with lakes and grottos and waterfalls and it, too, owes its present design to the genius of Napoleon III. The splendid old oaks and beeches are a great feature and this open space, which still retains patches of the former Royal Park, was kept as a game preserve for centuries. It is now divided into two by military parade grounds and so you have really two parks to choose from. One section, with its metro station, Château de Vincennes, has the little Lac des Minimes and an interesting Annamite temple decorated with bronze and lacquer, in use as a religious centre for the Indo-Chinese population of Paris.

The other half of the park, best reached from the Metro Porte Dorée, centres round the Lac Daumesnil, with its boats for hire and its café on an island. Here is yet another zoo which is being developed to form one of the largest outdoor and indoor zoos in Europe.

The Château is rather forbidding-looking, but it is the only medieval Royal residence left in the Paris region and was first used as a hunting lodge by the Kings of France as early as the twelfth century. By the fourteenth century it had been turned into a massive fortress; it was taken over by the English during the Hundred Years' War and it was here that Henry V died when he was planning to conquer the whole of France. When the Château at Fontainebleau was built, Vincennes fell out of use as a Royal residence but the park was kept for hunting and later the fortress was used as a prison. In the early part of this century the Château was gradually restored to its original state, and now it is possible to visit the former Royal apartment and some of the prison cells. The keep is very well preserved and the Gothic chapel, completed during the Renais-

sance, is more or less intact, but the fragments of original
stained glass are confined to the Choir. There is a Museum of
the Art of French North Africa close to the Bois de Vincennes,
in the Avenue Daumesnil.

X

EXCURSIONS

VERSAILLES – FONTAINEBLEAU – CHANTILLY – ST GERMAIN-
EN-LAYE – MARLY-LE-ROI – SENLIS – ST DENIS – CHARTRES –
RAMBOUILLET – MAINTENON

VERSAILLES can be visited from Paris by bus or train or
on a guided tour, in half a day. The normal approach
from the capital, at the Place d'Armes, gives a rather
disappointing view of the Palace, since the square is vast and
gravelled and bare-looking, even with the blue and gilt rail-
ings and elaborate gateways. The façade on this side has been
spoilt by the *pavillons* added in the eighteenth century,
although it is only from here that you can distinguish the
original hunting box of Louis XIII which Louis XIV insisted
should form the nucleus of the new palace. The statue of
Louis XIV in the main courtyard is immense and of no great
artistic value, but it is the key to the entire building which
was erected to the glory of the *Roi Soleil*. It is an effort to
visualise the palace with all the colour and movement of the

133

seventeenth century; the marble courtyard in front of the old *château*, gay with flowering bushes in tubs, the horsemen and soldiers clattering to and fro; gilded coaches rumbling along and elegantly-dressed men and women of the Court adding to the gaiety; and the King himself, who always played his part to the full, in ceremonial dress.

Louis gathered together the artistic genius of the seventeenth century with the ambition of building something much more splendid than any of the other French palaces. The architect, Le Vau, was faced with a great problem, since he had to build a seventeenth-century palace in the Italianate classical style and, at the same time, make it harmonise with the delightful original pink brick and stone *château*. Later, the architect, Jules Hardouin Mansart (1646– 1708) great nephew of François Mansart (1598–1666), added *pavillons* which combined well with the original façade and the chapel on the right, with its beautifully decorated interior.

Before going into the palace, walk through to the gardens and far enough down the steps to get a full view of the other façade, deceptively large in that it is immensely broad but very small in depth. Much of the grandeur is an illusion, helped by the splendid setting of wide gravel terraces, sweeping flights of steps, vast looking gardens, vistas and fountains, again all designed to make them look grander and more extensive than they really are. Here, too, in the splendour of the garden setting, the movement of the seventeenth-century Court is lacking, for the gardens and palaces were built to be thronged with people and the present day tourists do not compensate for the pageantry of past centuries.

From this side, the long horizontal lines of the classical façade completely cover the old *château* and the design is saved from monotony by the sculptured figures and motifs on the narrow balustrade hiding the sloping roof.

Louis XIV's minister of fine arts, Le Brun, was detailed to

carry out the interior decoration of the palace and to harmon-
ise furnishings and decorations, whilst Le Nôtre was entrusted
with creating the gardens in the unimaginative flat land round
Versailles. The very difficulty of the task spurred this talented
garden architect on to his greatest triumph, for it is a master-
piece of design and illusion where all defects have been masked
or turned into assets.

He dealt with the problem of the town being so close at
hand in the most brilliant manner. To the left of the *château*
the gardens are designed in great detail, with flower beds and
trees and statues, to direct attention away from the town which
he partially masked by trees. To the right, where the landscape
undulates a little and there are woods, the eye is skilfully taken
to the horizon, and a long distance view of woods gives the
illusion of extensive grounds all round.

There is no need to describe the palace in detail, for most of
the rooms must be visited with a guide who rushes one along
with large groups of tourists. Even so, by skilful manœuvring,
a few minutes more can be gained in the important places such
as the Opera House, the Chapel and the Hall of Mirrors. The
ante-room of the Opera has charming decorations by Gabriel
and the gilded carvings are altogether delightful; unfortun-
ately the sets have not been preserved so that ballets and operas
cannot be represented in their early form.

The Chapel has remained completely unchanged since it
was built, and keeps its painted ceilings and gilded ornamenta-
tions, typical of the Baroque period.

The *Galerie des Glaces* has the most lovely proportions of
any state apartments in Europe, reflecting as it does, all the
splendour of the gardens for the whole length of the gallery.
Again the impression is of greater size than really exists, since
everything is doubled and trebled by reflection and counter
reflection, and this called for gilt and colour and lightness in
furniture and furnishings and even in elaboration in clothes

and wigs so that people should not be too much diminished by constant reflection.

The ceiling, painted by Le Brun himself, is really magnificent and harmonises superbly with the glass and gilt. Do not leave the Galerie des Glaces without looking out of the central window to the glory of the gardens stretching to a ha-ha, which skilfully disguises the fact that the far countryside is not part of the estate.

To savour the particular attraction of the gardens, walk between the two artificial lakes, with their figures symbolising the rivers of France, and continue straight ahead past more fountains to the lovely fresh green strip of lawn, the *tapis vert* bordered with statues and urns. This leads to the Bassin d'Apollon where the lead group of Apollo in his chariot symbolises Louis XIV, and to the Grand Canal, a great stretch of water in the form of a cross. Even bringing water to this area was a major problem and waterworks were constructed at Marly to supplement the flow.

During the reign of Louis XIV, part of the grand canal was transformed into a miniature Venice, with models of palaces constructed on the banks and gondolas with lighted lanterns floating gracefully over the waters.

Radiating from the ornamental waters and fountains, avenues of trees give vistas of more statues and follies. A grove leads to the lovely Colonnade which gleams through the trees in its perfect proportions. It was built of marble by Mansart at the end of the seventeenth century and decorated by bas-reliefs, some of which are by Coysevox.

From the Bassin d'Apollon it is a longish walk along the Allée de la Reine to the little hamlet of Trianon which the King acquired in order to build a smaller residence away from the pressure of royal duties. This building did not last, so the king had the Grand Trianon built, a perfection of pink and white and grey marble on one floor, with an open colonnade.

Beyond, to the left, is the delicate little Petit Trianon in white, built by Louis XV for Marie Antoinette. To the left again, the *jardin Anglais* was laid out according to the fashionable taste of the day. A small path through the trees, leads to the *hameau*—the hamlet where the royal ladies played at being peasants.

In these gardens there is indeed enough to occupy many hours, strolling about through woods and groves and discovering still more statues and ponds and remote retreats.

* * *

The Château of Fontainebleau, only 60 kilometres from Paris, can be reached by train as well as by coach, but this does take longer, as the Gare de Lyon, from which the trains run, is far out in the east end of the capital. Also Aven, the station for Fontainebleau, is two miles from the Château but there is a frequent bus service and the walk through the park is pleasant. For those with a day or two to spare, there is a delightful hotel in the woods close to the station, and within easy reach of some of the Impressionists' favourite haunts on the Seine, such as Samois or Moret.

From the woods, the first view of the Palace is through a screen of splendid old trees and, since the main attraction of this particular *château* lies in its setting, this is a great advantage.

The Palace, in its present form, was built by Francis I who was also responsible for the very imaginative château of Chambord on the Loire. In both these palaces the king's attractive emblem of a Salamander is incorporated in the decorations. Since Francis I was a great admirer of the art and architecture of the Italian Renaissance, Fontainebleau was planned on the lines of a Tuscan Palace, and was decorated by Italian artists

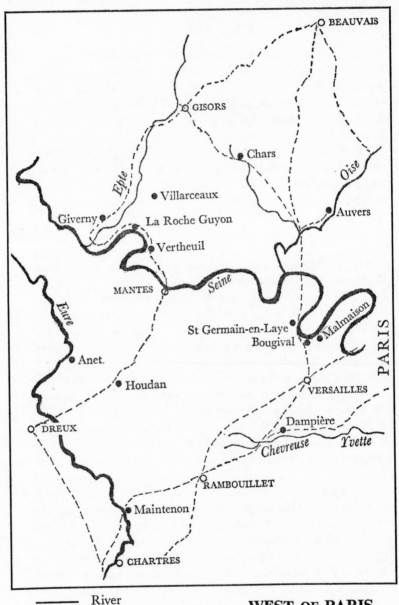

WEST OF PARIS

———— River
- - - - Indication of Route

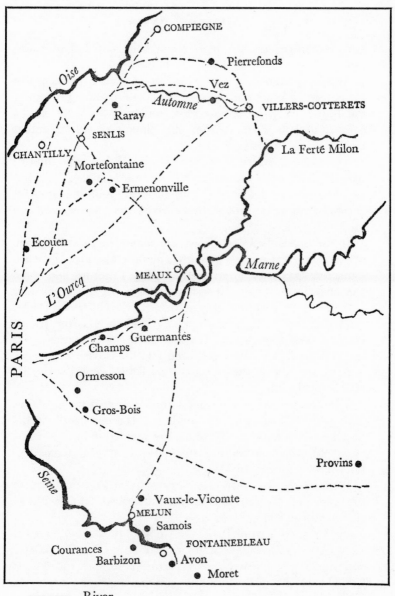

COMPIEGNE

Pierrefonds

Oise

Vez

Automne

VILLERS-COTTERETS

Raray

SENLIS

La Ferté Milon

CHANTILLY

Mortefontaine

Ermenonville

Ecouen

Marne

MEAUX

L'Ourcq

Guermantes

Champs

Ormesson

Gros-Bois

Provins

Seine

Vaux-le-Vicomte

MELUN

Samois

FONTAINEBLEAU

Courances

Barbizon Avon

Moret

PARIS

—— River
- - - - Indication of Route

EAST OF **PARIS**

and craftsmen, or by those trained in the Italian tradition.

Although Francis I encouraged great Italian painters like Leonardo da Vinci and Andrea del Sarto to come to France, the former was too old to leave much of his work in the country and the latter disliked the climate to such an extent that he quickly went back to Rome.

The *château*, which is only two storeys high, has no impressive sky line and looks rather gloomy on a sunless day, but the large courtyard is well proportioned and the graceful curves of the horse-shoe staircase break the monotony of the façade.

In the main, the interior decoration and the furnishings are not of very great interest or artistic quality, although there are some fine pieces of seventeenth-century furniture and some paintings by Boucher. Nevertheless there are three splendid galleries which are beautifully decorated : the Galerie de Diane, built during the reign of Henry IV and used as the palace library : the Galerie Henry II with frescoes by Primaticcio and restored mouldings and woodwork, and the Galerie François I with its sixteenth-century paintings by Rosso, depicting the life of this sovereign.

The grounds have a formal section designed by Le Nôtre and an English Garden. The pond attracts a number of visitors because of the famous carp which are reputed to be a hundred years old; they are more than willing to display themselves but are very repellent looking.

Incidentally, it is very easy to drive from Fontainebleau to the Château of Vau le Vicomte (described later) with its superbly beautiful gardens.

To the north east of Paris, the Château of Chantilly and of Compiègne are both reasonably easy of access, but the painter will surely give preference to Chantilly to visit the Musée Condé with its early paintings and manuscripts and to see

what are perhaps the most beautifully designed stables in the world.

The Château is about a mile and a half from the station but it can be reached through the forest. By this route you will first come upon the stables which themselves seem like a minor palace, with a main doorway and a graceful bas-relief of horses : even more delightful than Fontainebleau from the point of view of situation, Chantilly looks rather like a stage set, probably because it was heavily restored in the nineteenth century. It appears to rise out of the lake, like an enchanted castle backed by magic woodlands.

The collection of rare manuscripts and early paintings is of outstanding interest and the main picture gallery contains many famous works including paintings by Poussin, some seventeenth-century Florentine and sixteenth-century Venetian works and, in the Rotunda leading off it, a superb drawing by Watteau and a sanguine sketch by Rembrandt. A collection of exquisitely handled sixteenth-century drawings, mainly by the Clouets, are of documentary as well as artistic interest, since nearly all of them are identified. Here too, are paintings by Corneille de Lyon, Holbein and Rubens. *The Virgin* and the *Three Graces* by Raphael and the *Esther and Ahasuerus* painted on a marriage chest by Filippino Lippi are in the sanctuary.

The collection of miniatures painted by Fouquet for a Book of Hours, is infinitely lovely. Unfortunately the very precious *Très Riches Heures du Duc de Berry* cannot be seen in the original as it has become too frail to handle, but a copy of this magnificent book illuminated by the de Limbourg brothers is on view, and you can buy an expensive but very good replica, on sale at the entrance.

Compiègne is not far away, and the road to this Palace passes near Pierrefonds, a nineteenth-century restoration it is

true, but quite an effective one, of the type of castle illustrated with such delicacy in the *Très Riches Heures*.

* * *

The small *château* at Malmaison is very easy to reach by train from the Gare St Lazare and can be combined with a visit to St-Germain-en-Laye as it is on the same line. The chief attraction of Malmaison lies in its complete lack of formality and its air of a country residence set in a small park with gardens full of roses, and, of course, in its connections with Napoleon and with Josephine whose house it was, and who continued to live there after the divorce. The museum is of no great artistic interest, but there are a number of objects which belonged to the Empress, and furnishings and *objets d'art* connected with Josephine collected from various palaces belonging to the state.

The attraction of St-Germain-en-Laye lies not so much in the rather ornate and ugly pink *château* which overshadows the town, as in the broad terrace along a ridge above the valley of the Seine which gives extensive views across woods towards the capital. The Château was built by Francis I on the site of an old fortress and the Sainte Chapelle is reminiscent of the one in Paris but without its good proportions, delicate detail and stained glass windows.

There is a remarkable example of modern church architecture at Marly-le-Roi which lies between St-Germain-en-Laye and Versailles. Very effective use has been made of different materials and their varied textures : natural wood, stained glass, iron and stone and a 'spire' which, especially when viewed from inside, has the buoyant moving lines of a Viking ship and soars into the sky with Gothic grace and Romanesque majesty combined in a completely modern conception.

A number of other *châteaux* in the Paris region, less well-known to the public, will be described in a later chapter.

* * *

Senlis is easily reached from the Gard du Nord and, as it lies just beyond Chantilly, the two places can be combined. It is a small town with narrow winding streets flanked by graceful houses, old walled gardens and some sizeable mansions with wrought iron gates. The cathedral was one of the first churches in France to be built in the Gothic style and has carvings and bas-reliefs over the main portal which compare favourably with some of the work at Chartres and Rheims.

When most of the old ramparts were demolished, broad avenues were laid down and, to the south, a walk between the trees leads on to the remaining ramparts, part of which are Gallo-Roman, and afford a fine view over wooded country which is one of the main areas of stag hunting in France. The meets are still very colourful occasions with women in scarlet riding-habits and tricorns, and men in pink or green hunting-coats, all riding along the tracks threading between the great forest trees and the feathery saplings.

The average visitor to Paris may well be deterred from going to see the Basilica of St Denis because it is situated in an unattractive industrial suburb, but it is only ten minutes by train from the Gare du Nord. This building is of great interest to students as it plays a very important part in the history of architecture, for it was the first large church in the Gothic style and inspired twelfth-century cathedrals such as Chartres and Senlis. The amazing accomplishment of erecting this building in eleven years (1136-1147) was due to the zeal of Suger—the builder-priest who inspired Notre-Dame—and his parishioners who dragged carts of stone by hand from Pontoise which

was over twelve miles away. The church was enlarged in the thirteenth century and enriched with some priceless works of art, some of which are now in the Louvre, but in later centuries it fell into a state of decay and then was over-restored by Viollet-le-Duc in the mid-nineteenth century. From the exterior, the church has rather a depressing, sombre aspect since this very early Gothic lacked the lightness and magic of the later style.

During the Revolution, some carved figures of the Saints were removed from the west front under the delusion that they were portraits of the Kings of France; they belonged to the same period as those on the porch of Chartres and were designed in the curiously elongated style which harmonises so well with the slender lines of Gothic architecture.

The interior still retains some of the features of the time of Suger; early Gothic arches and pillars, but there is no original glass left in the nave which has been cut in two by a screen to protect the Royal tombs, the real glory of the Basilica. This section can only be visited with a guide since it was the burial place of the Kings of France from the reign of St Louis in the thirteenth century and many, if not all, of the later effigies are actual portraits, and therefore of great historic as well as artistic interest. During the Revolution, the tombs were ravaged, but many of the effigies were saved by an architect and re-erected during the Revolution.

It is impossible to mention all the tombs in detail, but among the more important are those of the members of St Louis' family which have a thirteenth-century grace and monumental quality but are symbolic rather than character studies. The monuments to Louis XII and his wife, Anne of Britanny, are by an Italian sculptor and therefore in the northern Italian Renaissance style, while the double Tomb of Henry II and Catherine de Médicis is very fine and is alone worth the visit to St Denis. Primaticcio, who was concerned with the decora-

tion of the palace of Fontainebleau, made the drawings for this tomb and it was carried out by the renowned French sculptor, Germain Pilon. He has depicted the reclining figures completely naked and relaxed in attitudes of peaceful slumber during their younger life but they are also shown beneath a canopy in their maturity, in court costume.

The ugly, courageous face of Du Guesclin, hero of the Hundred Years' War, is realistically reproduced and Francis I is seen kneeling beside his wife and children.

Although the tombs in the crypt are not of any high artistic value, the crypt itself is part of the original building and rather better preserved than the rest of the Basilica.

* * *

I have left the description of Chartres to the last because the cathedral is, without doubt, by far the most important piece of architecture which can be visited in a day from Paris.

The carvings and stained glass are unique and the town itself has a tranquility which even the ever increasing traffic and crowds of tourists have been unable to break. From a distance, the view of the unequal spires rising above the corn-fields and of a countryside of farmland and old farmhouses, is one of complete serenity, and the silhouette of the Cathedral, though irregular, has absolute perfection in its delicate lines and balanced proportions. It was rebuilt in 1194 on Roman-esque foundations which were all that remained of the former buildings after a succession of fires; most of the work was com-pleted by 1220 but the north and south porches were added later.

The simple lines of the south spire contrast with the more elaborate, but still lovely, lines of the late Gothic north spire and each complements the other as they surmount the solid

Romanesque tower; but the outstanding interest of the exterior is the magnificent series of carvings on the west front or *Portail Royal*. These graceful figures are elongated to conserve the slender lines of the shafts and become part of the architectural whole. The hair and the drapery are decoratively treated and add to the general slim effect of the building; the heads are full of character and each one has its own individual personality. All the small supporting figures also repay a detailed study. There are two carvings of Pythagoras and Donatus below the allergorical figures of Music and Grammar and both have an extraordinary depth of concentration expressed in their faces. The scenes depicted on the lintel are composed with genius, especially the Nativity and the Shepherds, with a look of wonder on their faces, being led to the Manger.

The tympanum of Christ Enthroned dominates the three portals of the west front with figures of angels and winged symbols of the evangelists depicted with all the grandeur and majesty of symbolic art.

The more deeply set south portal is decorated with less stylised figures that are set firmly on their feet with a grace of movement and harmonious flow of line, though they lose something of the simple splendour of the west front.

The interior of the Cathedral gives an impression of complete architectural perfection in the graceful proportions of pillars and satisfying curves of vaulting contrasting with the elaboration of the late Gothic choir screen. The twelfth- and thirteenth-century stained glass is of such perfection and brilliance that one's attention is inevitably drawn away from everything else until the rest of the building seems to be a framework for it. The incredible 'Chartres Blue' is enhanced by other deep jewel colours and not only do these windows let light through, but they seem to trap, intensify and diffuse it, sparkling when the sun shines, but holding a deep glow even on the

dullest day and enlivening the rather sad grey of the stone-work.

* * *

Both the Château of Rambouillet which is the Presidential residence, set in gardens open to the public, and the Château de Maintenon, which is partly Gothic but has a delightful Renaissance façade, with fourteenth-century round brick towers at each end, lie on the way from Paris to Chartres, but, attractive as they are, seem rather an anti-climax after the cathedral.

XI

WHAT TO DO ON SUNDAY

Forests, Valleys and Châteaux near the capital

Contrary to general opinion, Paris is not fundamentally any gayer than London on a Sunday, apart from the markets and the mid-day meal, but, as in London, there is plenty to do if you wish to stay in the capital. A great many cafés and restaurants are closed, but even so this is the day to take a long drawn out lunch at a popular local restaurant where entire families gather for a gala meal. The Butte Montmartre is at its best early on a Sunday morning before the tourists start streaming up and blocking the roads with cars around 11 o'clock. Until then, it keeps its air of a village and you can stroll about unhindered even in the Place du Tertre. Then, away from the central attractions, some of the outer lanes will still be deserted on the way down to the rue Lepic, with all its Sunday market bustle. There is usually a particularly good Sunday meal at one or other of the restaurants in or near the Place des Abbesses especially if it is filled with discerning-looking locals.

Not only are the flower and food markets, such as the Marché St Germain and the Buci, crowded and gay on a Sunday, but the huge flea market at the Porte de Clignancourt

is in full swing, with its four miles of stalls of antiques augmented by heaps of junk. An hour here fits in very conveniently with lunch in Montmartre as an easy métro journey connects the two places. There are also smaller markets at both the Porte des Lilas and the Porte de Vanves, and the very popular Village Suisse in the Avenue de la Motte-Picquet is open every day except Tuesdays and Wednesdays. However, if you want to try your luck at the numerous auction sales held at the Salle Drouot in the rue Rossini, you must go there on a Monday, Wednesday or Friday afternoon. You will be able to pay for your purchase and take it away immediately.

The bird market takes the place of the flowers in the Place Louis Lépine on Sundays and a dog market opens in the afternoon in the rue Briançon in the 15th *Arrondissement*. Unfortunately the horse, donkey and mule market held here also does not open on the same day.

Neither the central flower market nor the one at the Madeleine is open on Sundays, but there are plenty of smaller ones since so many people visit cemeteries on Sunday afternoons.

Sunday is an excellent day for looking at fountains and statues—the valiant bronze of Joan of Arc in the Place des Pyramides brandishing her sword and unfortunately garishly gilded by the Nazis, details in large fountains like those in the Place du Théâtre Francais and the Wallace drinking fountains with their graceful caryatids disposed over the Left Bank. Then too, the attractive Art Nouveau Métro entrances with their plant motifs are easy to find in Montmartre.

On Sunday it is possible to walk round the Marais in comfort, and there is some entertainment to be found in the clothes market in the Carreau du Temple, and there are a number of travelling fairs in different quarters. At Easter and in early October, the Foire à la Ferraille, in the Boulevard Richard Lenoir, displays all kinds of metal scrap and quite a lot of attractive cast- and wrought-iron junk.

Obviously these places are crowded, but it is part of the fun and certainly presents a good opportunity to make sketches of odd Paris characters. On the other hand, no one would wish to join the crowds at the larger museums and galleries on a Sunday as these, overflowing even on weekdays, double their numbers on the free day. Likewise all the more popular sights are crammed with people and so are most of the parks and easily accessible open spaces, for those Parisians who cannot get to the country like to be out and about.

Music in the main churches, especially Notre-Dame, St Sulpice and St Clothilde, is of a very high quality and can easily be combined with a day out in the country. Public transport is crowded on popular lines like the Ligne de Sceaux, but the distances are short, and all passengers tend to drift away as the train goes further out.

This Ligne de Sceaux is one of the great attractions of living within walking distance of the Luxembourg; from this station frequent trains go to the Vallée de Chevreuse, remarkably enough still unspoilt in its remoter parts, since excursionists tend to collect at the bars and restaurants near the stations served and motorists cling to the roads. For those painters who still like to work in the open air, this offers endless opportunities for landscape painting in a countryside not over picturesque but characteristically French, and entirely rural.

In 1863 when Cézanne went to live with Emile Zola in the rue Saint Victor, the two often spent Sundays together in the Vallée de Chevreuse finding subjects for landscapes. Much of the country they explored remains the same today, and there are still villages with a completely unspoilt atmosphere, with cottages and farms which might be hundreds of miles from the capital. In the late nineteenth century, it must have been sheer enchantment to get away from the popular beauty spots with their pleasure gardens, restaurants and all kinds of amuse-

ments to induce Parisians to spend money on Sundays and fête days. In this region, on the wooded slopes that dominate the Vallée aux Loups, there are still restaurants dating back to 1850.

Cheerful scenes of people enjoying themselves in the open air were often an inspiration to Renoir and Claude Monet, but Cézanne sought the unspoilt countryside and was deeply interested in the structure of earth and trees and hills. Here, quite near to Paris, were woodlands, slopes and valleys, farmsteads, orchards, gardens full of honeysuckle and roses, and even the small river Yvette, winding at the foot of the low, wooded hills.

The best thing to do is to take a ticket to the end of the line, St Rémy de Chevreuse, as passengers thin out as the train reaches the tourist attractions of Sceaux and Robinson—this latter a place where they can be served with drinks, seated on platforms erected in the trees. There is a bus from St Rémy out towards Dampierre where, if you slant away from the Château of Dampierre, it is possible to find relative solitude in the woods and hamlets. The main points of interest for sightseers are the seventeenth-century Château of Dampierre, with a gallery decorated by Ingres, the Port Royal des Champs, with the remains of an old abbey, and Vaux de Cernay, with its Cascades, but they all attract a lot of visitors.

Just as in all the forests and wooded valleys near any capital, it is unwise to penetrate too deeply into deserted patches of forest or wander into remoter areas alone, even in the Forest of St Germain and certainly the much vaster forest of Fontainebleau.

This last is easily reached from Paris and is of course very popular because of the Château and the wonderful walks it provides, but also because of its association with the School of Fontainebleau and of Barbizon. 'The 'village' of Barbizon is a nightmare on a Sunday, since it has been elaborately built up

and commercialised, though Moret, five miles beyond Fontaine-bleau, is so lovely that it is worth risking the crowds. It is situated right on the edge of the forest and just away from the valley of the Seine, on its tributary the Loing.

Sisley was continually painting Moret itself, its bridge, its church, its mills, and of course the river Loing. The painter's house which still exists, was well-chosen as a dwelling for his last years, for everything he needed as subject matter was within a short distance of his home. The famous bridge with its gate and church tower, immortalised by him, remains the same today, and on week days out of season, much the same kind of people make their leisurely way across the town. Many trippers stream out from Paris at weekends and during the summer, but it has always been a favourite place for fishing and riverside picnics. Sisley has expressed for us the light and colour, the warm rose and brown of the buildings, the lush grass, the flowing river and the slender trees. He gives us the full flavour of the place in all its moods and at all seasons. He paints the scene in its completeness as a landscape, for it was landscape that interested him rather than people.

Admittedly Moret is apt to be crowded on Sundays, but you may still be able to find a table on the river-bank, with the same view of the bridge and gateway that Sisley made famous : where women still do their washing from boats down below. Samois, where both Monet and Sisley painted the railway bridge, is not far from Moret or from Avon and is situated in a particularly beautiful stretch of the Seine; and, if you are lucky, it will be flooded with the beautiful light which inspired the Impressionists.

For lovers of unspoilt countryside, the forest of Fontaine-bleau has too many 'beauty spots', too many romantic-looking groups of rocks and 'sylvan glades'. Some of the very old oaks look almost like people and a village such as Barbizon has become veiled in a mist of souvenir shops, painters' taverns,

and unsuccessful attempts at picturesque villas. It is almost laughable in its extreme ugliness and it gains little by being less crowded on week days, for there is not even a nucleus of attraction. There is interest, however, in driving through the forest and seeing the kind of landscape and trees which so much attracted Théodore Rousseau, who specialised in doing what amounted almost to portraits of individual trees. Some of the remoter stretches still recall the settings where Corot found inspiration for his silvery, misty landscapes with a diffused light spreading through the trees.

But the forest, and more especially the Château, have much earlier associations for painters, since it was due to the great enthusiasm of Francis I for the arts that the School of Fontainebleau was established in the sixteenth century. This school was Italian in style, for its leading artists were the Italians, Primaticcio from Bologna (1504–1570) and the Florentine, Rosso (1494–1541) both assisted by a number of minor artists mainly from Italy. This school was therefore not really French, though it absorbed some French qualities and the Frenchman, Jean Cousin the Elder (1490–1561), attained considerable fame. The painters were chiefly absorbed in decorating the royal palace and, with the death of the principal artists and the Massacre of St Bartholomew, almost all artistic activity ceased until nearly the end of the century, when Henry IV revived the arts by commissioning Toussaint Dubreuil (1562–1602) to paint grandiose decorations again. The school kept its foreign character, for Dubreuil used a large number of Flemish assistants and was succeeded by Ambroise Dubois from Antwerp whose decorations, now destroyed, in the Diana Gallery, had a richness and ease of composition which rivals the more popular Primaticcio.

The conventional and royal quality of the school of Fontainebleau was entirely different from the school of Barbizon which flourished two centuries later, for the members centred

their activities round the forest rather than the Château, and concentrated mainly on landscape. Many of the minor character's names are almost forgotten, even though they were individualistic. Daubigny painted in the open air, from a barge, and Harpignes changed his job from commercial traveller when he was over thirty, to paint his quiet landscapes. Millet, who also settled in Barbizon, will always be remembered for his sentimental *Angélus* but perhaps also for his confident draughtsmanship and his ability to depict the earthiness of the land and the peasants working on it.

Corot is of course, the great name connected with the Forest, although he is apt to be discredited today as a mere painter of tones with no enthusiasm for colour and no real vigour, who in his later years turned out hundreds of paintings to a pattern. He admitted to being far more interested in tone than in colour, but he did create some magical shimmering landscapes with the most subtle colouring veiled in a silver light.

Even the Impressionists went out in this direction, roughly following the course of the Seine, but not necessarily to paint in the forest. For that matter, one or two of them disliked painting in the open air and went into the country to observe nature and enjoy a day off.

In 1890, when Degas was fifty-six, a considerable age for such a fussy hypochondriac, he went with a friend on a most original tour of the country near Paris. The two men took a cab, with the intention of covering about a hundred and fifty miles in three weeks, making halts where they could visit friends. They found an old white horse whose owner said he would astonish them with what his could do, and that he had a good character and even temper. All Degas' friends were very much interested in this excursion and made him promise to send them news whenever possible. The couple went to Melun, to Montereau and to Sens, through wonderful undulating country, miles and miles of which are still unspoilt.

As it was autumn, the lovely trees, reminiscent of Claude's poetic paintings, were aflame with brilliant colour. The river, as it wound through town and village, reflected the golden foliage, the russet roofs and the Gothic church towers. The sweep of the Gatinais, a completely rural heathland, hides in its folds small hamlets which do not boast even a café and would have afforded subjects for most of the Impressionists, but Degas was not interested in landscape and the idea of painting in the open air filled him with horror; he is reputed to have said : 'After all, the only way to produce a really good landscape is in the studio.' His racecourse scenes were conceived in the open air but virtually all his work was done in the studio, apart from sketches of figures or animals in action.

This was hardly the attitude of the landscape painters of his time who made a point of painting out of doors in all weathers, or at least painting from a window the scene that lay before them. With a few exceptions such as Cézanne, Gauguin and Van Gogh, they found most of their inspiration in the country near Paris and westwards to the coast.

It is still possible to spend weeks exploring the river valleys which spread out in all directions : the Seine, the Oise, the Ourcq and, rather further away, the Marne and the Yonne but, for those who prefer a definite objective to walking or painting, there are many *château* and medieval castles which are scarcely known to foreigners. A number of these are unique from the architectural point of view or have museums with exhibits of a high quality. Some which cannot be visited without special permission may at least be glimpsed from outside, but it must be remembered that entrance fees can be quite expensive and rather more than is usually paid in England. Of these, I can only mention a few, and I shall choose them mainly for their gardens, their art collections and for their setting, leaving out those in commercialised areas. Some are

near to better known monuments which have already been described, but a car is needed to see these less popular sights and, of course, a good map.

To the north east of Paris, in the Compiègne/Senlis area are three *châteaux* which could all be seen in one afternoon or combined with one of the larger sights as they lie almost in a straight line and within a few miles of each other.

Raray, just north of Senlis, which is mainly seventeenth century in style, is noted for its beautiful main courtyard surrounded by arcades with alternating niches containing busts of famous personalities. To these are added stag and boar hunting scenes. Visitors are allowed within this court and also can walk through the park to see the highly decorated Porte Rogue which was erected at the same time as the Château.

Further east and on the other side of the river Automne, lies the Château de Vez on wooded slopes above the valley. The fourteenth-century castle was built on far older foundations and the chapel houses a museum of objects from this royal province of the Valois and includes prehistoric and Gallo-Roman exhibits mainly from the extremely interesting hamlet of Champlieu at the southern end of the forest of Compiègne. This really merits a separate excursion and its second-century remains and catacombs are chiefly of interest to specialists.

The church in the village of Vez is worth more than a casual look for its façade and tower are twelfth century and there are sixteenth-century paintings in the interior. To the east again, the Renaissance *château* of Villers-Cotterets has a decorated staircase. The park has a huge lawn surrounded with splendid old trees which replace the original gardens laid out by Le Nôtre, and, beyond, there is a wonderful vista through the forest for about two miles through the Royal Avenue.

South east of Senlis lies the romantic forest and village of

Ermenonville where Jean-Jacques Rousseau came to die in a small cottage near the *château* of his friend the Marquis de Girardin and found great happiness in this tranquil country-side for the few remaining weeks of his life.

The Château de Girardin is privately owned but the park, which is a marvel of landscape gardening, is open to the public. It is of exceptional interest since Girardin was an enthusiastic garden-architect and even wrote a book on how to modify existing features of the landscape and 'improve on Nature' to make a beautiful garden. He certainly succeeded in turning what was wasteland and marsh into a lovely park with an English garden. Trees were grouped to give the best effect and avenues gave vistas of the temples and monuments he erected. The lake, with its cascades, had a small island—the Ile aux Peupliers—where Rousseau was buried among the poplars. His ashes were later taken to the Panthéon.

Of more especial interest to painters are the village and woods and ponds of La Mortefontaine to the west of Ermenon-ville. Apart from its association with Watteau, this is a region of sheer enchantment at any season or time of day, but with the changing light of early morning or sunset it becomes a land of fantasy. Silver birches and poplars and beeches border wandering streams and, deeper in the woods, still ponds gleam through the tree trunks. Unfortunately neither the Château nor the Park of Vallière can be visited, but it is possible to get more than a glimpse of the grounds from the narrow winding road to Thiers which passes by the main gates and between woods surrounding the lakes. In autumn, the wide iron gates and open railings reveal monumental trees in groups and rows, of reds and golds varying in intensity, and a vast sweep of intensely green and well-clipped grass slopes down to the lake with its islands. It was here that Watteau may have found the setting for his magical *Embarkation for Cythera*; it was here too that the poet Gérard de Nerval met Sylvie, the great love

of his childhood, the graceful young girl who so greatly in-
fluenced his life and his writing.

Corot has left us more than a fleeting memory of this fascin-
ating, almost mysterious region, in his *Souvenir de Morte-
fontaine*, which so perfectly re-creates its veiled tones.

A few more attractive *châteaux* lie very close together further
south and only a few miles to the east of Paris. Of these,
Champs is by far the most important, if only for its lovely
gardens which are still kept up in the original eighteenth-
century style; laid out by a nephew of Le Nôtre, the lawns and
fountains, glades and arbours are still a great attraction. Its
eighteenth-century decorations and furnishings are of the
greatest artistic interest. The music room has a remarkable
trompe-l'œil ceiling and from the windows there is a wonder-
ful view of the lay-out of the gardens. Perhaps the Madame de
Pompadour room is the most delightful, decorated with panel-
ling and chandeliers in the Louis XV style and palely delicate;
or the Chinese room, with its fascinating ornamentation.
Champs was owned by a succession of financiers who had
amassed enormous fortunes very quickly. When the first owner
defaulted, the son of a Breton peasant, who had become colos-
sally rich, bought the *château* because his wife, a former
domestic servant, was born in the village. It was he who erected
the present building where he lived in great luxury. His fabu-
lous wealth was looked on with suspicion or envy and he was
sent to the Bastille on some pretext, and only released on pay-
ment of an enormous fine which ruined him. The *château*
later passed through many hands and was, at one time, rented
to Madame de Pompadour. At the end of the nineteenth
century, the Comte Cahen d'Anvers acquired it, gradually
restored it, and finally his son gave it to the state. It is now
the residence of the Prime Minister of France.

After Champs, the other nearby *châteaux* are a slight anti-
climax. The Renaissance-style building of Ferrières-le-Brie is

F

visible through the iron gate. Guermantes is also privately owned, but visits are allowed on Sundays and holidays. Built in the seventeenth century, in brick and stone with some later additions, the interior has Louis XIII panelling and ceilings. The picture gallery is beautifully lit by eighteen windows but it contains mainly copies of no great interest. The gracious home of the de Bragelongue family, the Château de Jossigny, has the welcoming atmosphere of a house that is very much lived in and beautifully furnished in Louis XV style.

A little further south, Ormesson in its Renaissance splendour does not welcome visitors, but Gros-Bois does, with Son et Lumière in the summer and visits all the year round. This is another Renaissance *château* but furnished in the Empire style.

Further south-east of the capital and close to Fontainebleau, the Châteaux of Courances and Fleury-en-Bière are within a few miles of each other. Courances is not open to the public, but from the very beautiful parks and gardens there is a splendid view of the sixteenth-century building surrounded by the waters of the river Courances. The gardens behind the Château were designed by Le Nôtre, and have his characteristic fountains, flower beds and a grand canal. The sixteenth-century Château of Fleury-en-Bière has an imposing court and is built of brick and stone, with a huge round tower at one end. The former Romanesque chapel is now the parish church. North west of the capital, a little to the south of Gisors, the Château of Alincourt, Aleville and Villarceaux can conveniently be visited in one expedition, with the possible addition of Vigny which lies a little to the east of them.

Alincourt, delightfully situated in a wooded dip in the forest, displays a number of battlements and turrets of different periods, whilst the entrance gate is in the style of Louis XV. There is nothing of outstanding artistic interest in the interior but the park, with its old trees and two ponds, is peaceful and

secluded for a walk. The very attractive Château d'Ambleville is situated in the valley of the Aubette, a little river which runs between poplar trees through fields, the typical pastoral country-side of northern France. The interior is worth visiting, and there is an Italian garden. The village of Omerville has a fifteenth-century manor house, now occupied as a farm, a church dating back to the eleventh century and an even more ancient stone cross. The romantic buildings of Villarceaux cannot be visited but the eighteenth-century *château* and the fifteenth-century manor house where Ninon de Lenclos hid her lover, Louis de Mornay, were both built in the extensive park and are reflected in the formal waters.

The Château of Vigny, although very much restored, has the appearance of a Renaissance palace of the banks of the Loire and the whole façade can be seen from the gateway, but it can be visited for the Son et Lumière performances on sum-mer evenings.

The Château of Anet, west of Versailles, was a vast domain in the sixteenth century but is now very much reduced in size, though the imposing entrance still remains, together with one wing of the former *cour d'honneur*. The actual gateway is a kind of triumphal arch, with bas-reliefs of Diane de Poitiers. The clock above is an elaborate construction, with dogs and a stag which formerly sounded the hour by barking and stamp-ing. A stone bridge over the moat replaces the former port-cullis. Needless to say, the interior is full of souvenirs of Diane de Poitiers, and it also has some superb sixteenth-century tapes-tries from the workshops of Fontainebleau.

Diane de Poitiers was, first of all, mistress of Francis I and then of his son Henry II, and she commissioned the construc-tion of the Château of Anet as well as of Chenonceaux which is built on a bridge bestriding the river Cher, a tributary of the Loire. Daughter of one of France's noblest families, she had induced Francis I to spare the life of her father who had been

accused, with very good reason, of high treason. She was widowed when she was still young and, perhaps because black suited her, she wore mourning for the rest of her life.

XII

PAINTERS' COUNTRY

Between Paris and the Channel – Places where some of the Impressionists lived.

ALTHOUGH it is easy enough to reach the coast from Paris in a day, the country on the way is still so attractive that it is worth while prolonging the drive by a day or two, staying overnight at one or other of the off-beat villages on the way. To see the places where Impressionists and other painters sought inspiration, it is best to keep more or less along the valley of the Seine, with deviations into tributary valleys which are still rural. The west of the Ile de France still remains one of the most beautiful, luminous regions in the whole of the country. Needless to say, the places on the river near Paris are now part of the city overflow, but they are nevertheless interesting to visit, since so many painters lived or worked there.

Alfred Sisley, who was born in Paris of English parents, found this part of France ideal for painting and he and Camille Pissarro, more than any of the other Impressionists, have made the small places in the Ile de France familiar to us : Louveciennes, Bougival, Marly, Sèvres, Meudon, Saint-Cloud, Pontoise—hardly retreats for painters nowadays, but the light of

Paris and the Ile de France does not change, and even over-
built and spoilt parts of the riverside are suddenly transformed
by it, as we turn a bend and come across some ancient trees,
a grassy bank, and a house a hundred years old. It was Sisley
who took the famous trip down the Seine with Renoir in a
sailing boat, a venture which, taken in all the enthusiasm of his
student years, gave Sisley an enduring passion for the gentle,
undramatic landscape which furnished subjects for so many
of his most appealing pictures.

It is still a great experience to go down to the Seine, but much
of the trip from Paris is through suburbs, towns and built-up
areas—built-up, that is, with the hideous suburban villa archi-
tecture which the French have produced during this century.
In Sisley's day, even on the outskirts of Paris, the scene had a
rural aspect and the river flowed between orchards and fields
and woods, past farms and villages which afforded the young
men all the subjects they needed.

Since the Seine makes deep hairpin loops to the west of
Paris, mostly through what are now depressing areas, there is
no point in following the bends of the river close to Paris. Even
so, it is interesting to note that two of Seurat's greatest paint-
ings were inspired by the Ile de la Jatte and the river at
Asnières, this last being the setting of his famous painting of
The Bathers.

To see the more attractive places further afield, cut across
westward from Paris to the first place of any real interest—
sentimental or otherwise—Bougival, on the loop of the Seine
just south of St-Germain. There Renoir and Monet loved to
paint. The two friends painted several versions of *La Grenou-
illère*, a sort of restaurant-cum-bathing establishment on the
opposite bank, and a place which attracted the Impressionists
with its gay crowds and cheerful movement, its rural setting
and the graceful trees reflected in the water. Here, faced with
this lovely spectacle, the two artists made all kinds of discover-

ies about colour and light in their enthusiasm to catch the radiance and atmosphere of the scene. They found that by using broken brush strokes they were able to catch the ripple of water, and by spots of rainbow colour to recreate the shimmer of the trees. On the banks of the Seine, these young men argued and discussed and experimented, and put into practise an approach to nature and the painting of landscape which was to be of such great importance, not only to the Impressionists, but to the whole conception of landscape painting since that time.

Louveciennes is only a mile or so from Bougival and it is still just possible to visualise the road into the village which Pissarro painted in 1870 and again in 1872, and Sisley's *Road through Marly*, for the same trees grow tall and slender, to fan out in a vigorous tracery against the sky and the same glorious light radiates across the landscape. Perhaps more than any of the other nineteenth-century landscape painters it is Sisley who gives us the most intense feeling of the weather conditions, as for example when in *Snow at Louveciennes* he catches the mesmerising unreality of newly fallen snow. In *The Boat during the Flood* we feel the dampness in the air, the extent of the flooding, the houses reflecting the increasing light in the blue sky flecked with the scurrying clouds. In another painting of the same subject, he gives us a menacing sky, though light brightens the waters which reflect the houses and trees.

Even as near Paris as this, it is possible to drive along forest roads which are little used except in high season and at weekends and, in a journey back to the coast, there is no need to use any traffic-filled highways.

A road leads across the Forest of St-Germain, which roughly fills the next large northwards loop of the river to Pontoise. Despite the fact that this is quite a busy town, there are some vestiges of the picturesque place where Pissarro painted for so many years. In his early landscapes he chose the quiet,

St Germain-en Laye

familiar scene and was content to portray the winding, steep streets, faithfully rendering the landmarks and the atmosphere. Of these, *A Path at Pontoise* is one of the most lovely. It was painted early in Pissarro's development while he was searching for a means of expressing all the atmosphere impact of a lovely summer day. He had not yet joined the Impressionists, nor was he consciously following the aims of the group. He infects us, nevertheless, with his excitement at finding means of expressing light and heat and sunshine, and the charm of the arcadian country to be found at that time near a riverside town of this kind. In this picture, he gives us the gentle, satisfying rhythm of the countryside, the tranquil orchard sloping down to the peaceful little town and the level, sandy path on the ridge.

How often Pissarro paints a road or a path! *A Street in Pontoise, A Road in Versailles, The Road to St-Germain*, and, in Paris, the street scene—*Le Boulevard des Italiens, Le Boulevard Montmartre, La Rue Saint-Honoré*. He obviously loved roads and they give point to most of his pictures with their atmosphere of definitely leading us somewhere as lovely as the place he is already showing us. In the *Road to Saint-Germain*, the brilliance and force of the subject depicted in such strong definite colours holds our attention, but we are also drawn along the road to the misty blue distance which promises so much.

Pontoise still keeps some of its old attraction in its pleasant position dominating the Oise and the Valley of the Viosne, and the great destruction wrought by the Second World War has been most satisfactorily repaired. It would indeed be a pity to miss the Church of St Maclou which was built in the twelfth century and modified several times up to the sixteenth century. The façade has a Gothic portal, a tower and a rose window of the flamboyant period, but the tower was surmounted with a small Renaissance dome in the sixteenth century. In the interior, the plain Gothic columns contrast well with those of

the Renaissance period which have decorative capitals and, in their turn, differ from the more simple Romanesque capitals. There is some excellent sixteenth-century stained glass and a beautiful fourteenth-century statue of the Virgin.

The church of Notre-Dame was built at the end of the sixteenth century on the ruins of an earlier edifice and contains a thirteenth-century *Virgin* as well as a rare tomb of the first half of the twelfth century. For the inveterate sightseer, there is even the Musée Tavet-Delacour installed in a fifteenth-century mansion which has a number of very well displayed, more or less interesting exhibits, the least attractive being a mummified leg of Catherine de Médicis.

Chars, a village 15 miles away, along the valley of the Viosne, has a church which was built in the twelfth century but modified in the thirteenth and sixteenth century, and the transept and choir of the church at nearby Santereil are both Romanesque. Many a village church in this valley which winds westwards from Pontoise is well worth looking at.

Those interested in the Impressionists would do well to follow the Oise up north to Auvers and on a quiet and sunny day it is possible to recapture all the magic of the late nineteenth century when Cézanne, Pissarro and Van Gogh were painting there. It was there too, that Daubigny had a house and made himself a studio barge so that he could watch the changing light more effectively.

The site of Cézanne's masterpiece, *La Maison du Pendu*, can still be seen, though it is not of any interest now, for the houses have been altered and have no longer any great attraction.

It was in 1890 that Van Gogh came to live at Auvers, on the advice of Pissarro who wanted him to be under the care of his friend Dr Gachet. Pissarro would have put him up at Eragny, but his wife was fearful for the children and would not consent, in case he should become violent. So Van Gogh went *en pension* at the *Café Ravoux*, though he made a second home

at Dr Gachet's, spending long hours there with the specialist who had been such a friend of the Impressionists in Paris before his retirement in 1872. Van Gogh has left us portraits of the delightful sensitive doctor with the attractive face and deeply intelligent eyes, who was himself an amateur artist of some merit and a perfect companion for the half-crazy painter.

Van Gogh seems to have found the muted radiance in these northern parts no hindrance to his painting and stated that his studying the strong brilliance of the south had helped him to appreciate the subtleties of the softer light of Auvers. He painted the river, the trees and the fields of wild flowers, the church and the town hall, the peasants and the vast expanse of sky. His palette changed from brilliant burning yellow to white and pink, soft blue and green, but his painting was still forceful, though often tormented with a tortured line, swirling clouds and whirls of foliage. A long stretch of fields under a dark, stormy sky, a cornfield with great black birds wheeling menacingly across the almost indigo sky make the threatening macabre picture, full of impending doom, painted in July 1890.

It was on the 27th of that month that, overcome by despair and in a deep depression, certain that he was nothing but a burden and a failure, Van Gogh went out into the fields and shot himself in the chest. His brother reached his bedside in the *Café Ravoux* in time to see him die, and to give him all his affectionate assurances. This time Theo could do nothing to save his brother, and he himself, overcome with grief, began to fail in health and, six months later, died in Holland. He was buried in the cemetery at Auvers-sur-Oise next to Vincent, where two simple stones mark the graves.

The miniature town hall which Van Gogh painted, bedecked with flags, still stands near the *Café Ravoux*, now called the *Van Gogh*. It has simple wooden benches outside and bright checked curtains, and still keeps the painter's atmosphere

alive by displaying modern pictures in the main room. Of course, the nostalgic element has been emphasised, but not unpleasantly, and the price of meals is far from exorbitant for a place with such dramatic associations.

The church, serenely Gothic, is tame and colourless after the twisting tortured structure that Van Gogh gives us, but the great sweep of fields beyond is almost unbearably tragic in their association, with the trees and church tower silhouetted against the wide sky and the cemetery isolated on the hillside.

After the tortured drama of Van Gogh's setting it is soothing to pick a route south west through the quiet landscape and rather sleepy country to Vétheuil on a northward bend of the river. Here Monet settled in 1878 and painted the village and the river in every possible aspect of light, including deep under snow and lost in the haze of sunset colours.

A few miles away along the river, La Roche Guyon is naturally picturesque and almost a stage-set with its fountain and houses disposed at the foot of a castle which clambers up a crag. At this point the river takes a swerve south again to Giverny on the river Epte which flows into the Seine, still very quiet and countrified, but with the slightly forlorn air of a place whose week-end visitors have forsaken it. The attraction of the village lies in its variety and the peaceful setting of tall poplars, whispy willows and rolling pastures. There are several places to stay, but the famous *Bandy* is closed and appears derelict.

There is something almost uncanny about Monet's garden, on the route to Gisors, which has recently been carefully tended and restored to its former appearance. It seems incredible that one can look down from the railway embankment onto the water lily pond, the flowers brushed by the swaying leaves of willows and the frail little Japanese bridge still spanning the pond. Incredible too, to see the familiar rose pergolas leading

to the front door of Monet's house on the other side of the road, and to read on the plaque at the entrance gate that Monet lived here for 43 years and that he was still alive in the summer of 1926. Fruit trees and rambler roses and the familiar country cottage flowers that Monet loved—asters, Michaelmas daisies and sunflowers—still grow in profusion.

It was not until Monet was over fifty and at last successful that he was able to buy the house at Giverny which cost him 80,000 francs. He then embarked on extending and elaborating the wonderful garden which was to furnish him with so many subjects in his old age. He became more and more enthusiastic about this garden which he had transformed from 'a miserable orchard'. He diverted some of the waters of the Epte to form the famous lily-pond and when the flowers began to bud, he found it sheer enchantment. Water-lilies became a passion with him, and he painted forty-eight canvases of the flowers, the depths of the pond, the trees surrounding it, and the little Japanese bridge. He painted them at sunrise, in the mist, in the evening, at sunset and in full sunlight. He never seemed to tire of the subject even in extreme old age and when he was nearly blind.

Such was Monet's energy even during the last years of his life, that, in 1916, he had a second garden studio built and began working on the *Nymphéas* decorations which took him the rest of his life to finish. In 1918, Clemenceau paid a visit to the celebrated garden, to choose which of the series should be given to France. When the State asked also to buy an early work, the old painter had the satisfaction of insisting on their having the *Femmes au Jardin* which had been refused by the Salon fifty years earlier.

Although for the last few years of his life, Monet's sight deteriorated so that he could see very little and that with one eye, he was only totally blind for a few days before his death at the age of eighty-six in 1926.

La Roche Guyon

The boy who had, at first, ridiculed Boudin's suggestion that he should paint landscape, became a painter who was happier in the open air than anywhere else, happier painting in a garden or by the sea in a raging gale, recording his magical vision of nature.

Octave Mirbeau, the critic who greatly admired his painting, gave the following description of Monet at work :

'He lives in the country, in the most delightful scenery, with the open air as his only studio. You can see him installed there at dawn, even if it snows or a gale is blowing or the sun blazes down with its torrid heat; he is there, seeking new horizons, anxious always to find something better, to discover a pattern he had not perceived before, to seize a shade of colour which had hitherto escaped him.'

It is particularly beautiful along the Valley of the Epte which leads northwards from Giverny towards Gisors. The river flows between gently undulating hills and is lovely in the autumn. At that season, the ploughed fields, with their furrows stressing the lines of the land, are splashed now and then with patches of brilliant yellow, contrasting with frail-looking feathery trees on the skyline. Flowers still bloom in the hedges and fields, and a mass of wild plants and grasses take on their deep autumn colour. The tall trees turn from the cabbage green of late summer to dusty olive, with tinge of gold and orange. Avenues of poplars expose the tracery of their branches and the nest-like bunches of mistletoe obscured in the summer.

Gisors makes a very good place for an overnight stay. Admittedly the large square does look a little sparse and new, since it was very badly damaged during the Second World War, but the eleventh- and twelfth-century fortress still dominates the town and the river Epte, prettily edged with flower beds, runs through the town. The church, which is in course of restoration, presents a number of different styles, from the thirteenth century onwards and, as recent discoveries have dis-

closed, has foundations of a very early date. It is rather a
medley despite its fine details of carving and the recently
restored parts of the interior have a cold effect.

Though Beauvais was so badly damaged in the Second
World War, the Cathedral remains intact, with its lofty,
clustered pillars soaring up, storey after storey, their height
accentuated by the small area of the unfinished nave. Parts of
the interior have undergone a notably successful restoration,
worthy of the original feat of architecture, overwhelmingly
beautiful in the soft, creamy gold of the stone and the brilliant
windows. Beauvais has a particularly good collection of stained
glass from the thirteenth to the sixteenth century, to which
must now be added modern glass, replacing some that was
destroyed or damaged. These new sections are definitely
modern but incorporate something of the medieval tradition
with their glorious deep reds and blues marrying perfectly with
the Gothic architecture.

From Beauvais it is easy to reach the channel ports of
Dieppe, le Touquet, Boulogne or Calais, but as Boulogne is
more convenient for Kent, I usually go almost directly north,
sometimes deviating a few miles eastwards to Amiens cathe-
dral or by-passing this town and stopping to look at the magnifi-
cent reconstruction of Abbeville, after the extensive damage
from the bombardments of the Second World War. The road
leads on across the Valley of the Somme to Montreuil and
the *château* hotel on the height, owned by a noted English dilet-
tante.

There is a temptation to dally in the old town, with its
immense square and streets lined with eighteenth-century
houses. Montreuil is surrounded by massive ramparts which
overlook the countryside. A steep road winds down through a
belt of gardens to the plain and the main highway to Boulogne.
Though the outskirts of this harbour are rather tawdry, the old
town on the hill is also girdled by solid pink ramparts that

tower above trim flower beds. A broad street descends past the
market to the quays of the busy port, with its tremendous
activity of fishing boats and the strong smell of fresh fish and
salt water which, for some mysterious reason, assails one more
intensely here than in any other fishing port in Europe.

L'Epte

PARIS MUSEUMS

Musée de l'Armée, Hôtel des Invalides.
Open daily exc. Sun., Mon., Tues., and Jan. 1, May 1, Nov. 1.,
Dec. 25. 10–12.15. 1.30–5 (Nov. 1–Apr. 1); 10–12.15. 1.30–5.30
(Apr. 1–Oct. 1).

Musée des Arts Décoratifs, 107 rue de Rivoli.
Open daily exc. Tues. and holidays. 10–12. 2–5.

Musée National d'Art Moderne, 13 Avenue du Président Wilson.
Open daily exc. Tues. and holidays. 10–5.

Musée des Arts et Traditions Populaires, Palais de Chaillot.
Open daily exc. Tues. and holidays. 10–5.

Musée Carnavalet, 23 rue de Sévigné.
Open daily exc. Tues. and holidays. 10–12, 2–5.30 (Mar. 1–
Oct. 30).

Musée Cernuschi, 7 Avenue Velasquez.
Open daily exc. Tues. and holidays, 10–12, 2–5 (Oct. 1–Apr. 1)
10–12, 2–6 (Apr. 1–Oct. 1).

Musée de Cluny, 6 Place Paul-Painlevé.
Open daily exc. Tues. and Holidays 10–12.45, 2–5.

Musée Cognacq-Jay, 25 Boulevard des Capucines.
Open daily exc. Tues. and holidays, 10–12, 2–6.

Atelier de Delacriox, 6 rue Furstemberg.
Open daily, 10–12, 2–6. Closed Nov. 1–May 1.

Manufacture des Gobelins, 42 Avenue des Gobelins.
Open Wed., Thur., Fri. 2–4. (Open only for special exhibitions).

Musée Guimet, 6 Place d'Iéna.
Open daily exc. Tues., and holidays, 10–5. Free lectures Sat.,
Sun. (Jan.–Mar.).

Musée Nationale d'Histoire Naturelle, Jardins des Plantes.
Open daily, exc. Tues.

Musée de l'Homme, Palais de Chaillot, Place du Trocadéro.
Open daily exc. Tues. 10–6.

Musée Jacquemart-André, 158 Boulevard Haussmann.

Galerie du Jeu de Paume, Place de la Concorde.
Open daily exc. Tues. and holidays. 10–12.45, 2–5.

Musée Marmottan, 2 rue Louis-Boilly.
Open Sat., Sun., 2–5. Closed July 15–Sept. 15.

Musée des Monuments Français, Palais de Chaillot, Place du Trocadéro.
Open daily exc. Tues. and holidays, 10–5.

Musée Nissim de Camondo, 63 rue de Monceau.
Open daily exc. Tues., 2–5. Sun. 10–12, 2–5. Closed July 14–Sept. 15.

Musée de l'Opéra, Place Charles-Garnier.
Open daily exc. Sun. and holidays, 10–5. Closed for 2 weeks after Easter.

Musée de l'Orangerie, Place de la Concorde.
Open daily exc. Tues. and holidays, 10–5.

Musée Rodin, 77 rue de Varenne.
Open daily exc. Tues., 1–6 (Apr.–Nov.). 1–5 (Nov.–Apr.). Sun 1–5.

Maison de Victor Hugo, 6 Place des Vosges.
Open daily exc. Tues. and holidays. 10–12. 2–5. (Oct. 1–Apr. 1) 10–12, 2–6. (Apr. 1–Oct. 1.).

LIST OF PAINTING 'ACADEMIES' IN PARIS

Atelier of Ecclesiastical Art, 8 rue Fustemberg, Paris 6^{me}. Telephone : 633–13–67.
Specialising in drawing, painting, and the different techniques used in religious art including frescoes, stained glass, tapestry, iron work and sculpture.

Académie Charpentier, 73 rue Notre-Dame des Champs, Paris, 6^{me}. Telephone : 033–31–12.
Prepares students including foreigners for all the main schools of art, and also specialises in interior decoration.

Atelier Del Debbio, sculpture, art and technique, 11 impasse Ronsin, Paris, 15^{me}.
Specialises in the training of professional sculptors. Courses of modelling and drawing from the living model.

School of American art of Fontainebleau, Château de Fontainebleau.
A general school of art essentially for Americans but accepting the occasional foreigner.

Atelier de la Grande Chaumière, 14 rue de la Grande-Chaumière, Paris, 6^{me}. Telephone : 033–31–12.
Provides complete course in art training but is especially popular as a place where anyone can go to draw from a model, at set periods, and for a small fee per hour.

Académie Julian—Rive gauche, 31 rue du Dragon, Paris 6^{me}. Telephone : 222–55–07.
Provides a general course on art but is, for the foreigner, one of the most popular and stimulating places in which to sketch among artists and students of all nationalities.

Académie Julian—Rive droite, 5 rue de Berri, Paris 8^me.
As above.

Académie Notre-Dame des Champs, 56 rue Notre-Dame des Champs, Paris, 6^me.
General course. The studios are open for life drawing from 2 to 5 and the school does not close for the holidays.

Académie de la section d'Or, 11 rue des Sablons, Paris 16^me.
Telephone : 553–47–38.
General course and preparation for the Ecole des Beaux Arts. Sketching on Saturday mornings. In the suburb of Neuilly.

Atelier Szabo (Académie du Feu), 22 rue Delambre, Paris 14^me.
General course open from 9 until 9.30 at night and has a country *château* at St Just-en-Chaussée (Château de Ravenel) where students of the arts, under 30 years old, can work or holiday for a moderate price, and even have free riding.

Académie Frochot, 15 avenue Frochot, Paris 9^me. Telephone : 874–82–09.
The school is installed in the former studio of Toulouse-Lautrec and has general courses for foreigners.

Courses on Fine Arts
For admission to the Académie des Beaux Arts or the Ecole des Arts Decoratifs, apply to the school concerned.

Courses on History of Art at the Ecole du Louvre
A series of lectures open to the public free of charge but each member must obtain a card of admission.

The same lecture can be attended on either Tuesday, Thursday or Sunday of each week beginning in October.

Holiday Courses. Approximately 75 Fr.
A series of lectures on French Art are given from 10–12 on weekdays throughout July and are followed by an examination. Accommodation can usually be arranged in hostels.

Three Year Degree Course open to students of any nationality who have passed the equivalent of the *Baccalauréat.*
Foreigners may attend for only one year if they wish, but will not then qualify for a degree.

For further particulars apply to the Ecole du Louvre, 34 quai du Louvre, Paris I^e.

N.B. It is essential to have a good knowledge of French.

Special visits to Historic Buildings

Visits to special buildings can be arranged by applying to : Monuments-historiques, 62 rue St Antoine, Paris 4^e.

There is a small lecture fee plus entrance charge.

INDEX